"Dr. Florescu's focus on intersectionality in plays written by Romanian female playwrights is an admirable endeavor given both the scarcity of materials on Romanian cultural intersectionality and theater in general in the United States curricula. Not only are the ten plays included for discussion in this book a splendid sample of Romanian theater, but also the carefully structured analyses and activities, prefaced by photographs from performances, make this book a labor of love."
 –**Dr. Adriana Cordali** author of *Visual Rhetorics of Communist Romania: Life Under the Totalitarian Gaze*

"Designed as multilingual and multidimensional, this volume presents a series of plays by female artists who are deeply connected to Romania, Dr. Cătălina Florina Florescu's native country. Their engagement with intersectionality becomes evident not only when discussed by Florescu, but also when the playwrights are given a selfless chance to reflect on their own works. Shining a bright light on the urgent political issues and innovatory theatrical strategies at the heart of these contemporary productions will definitely stir interest and debate, proving the timeliness of the current project."
 –**Dr. Ludmila Martanovschi,** Secretary of the Society for Multi-Ethnic Studies: Europe and the Americas (MESEA)

"A compassionate and intimate exploration of female playwrights in Romanian theater presented to the global public through the lens of intersectionality as a tool for discernment of how the invisible power relations create inequality. Catalina Florescu masterfully uses her multifaceted roles as a woman, immigrant, mother, partner, author, and professor to examine the still vastly unexamined role female artists have in making intellectually stimulating art and leaving their beautifully diverse legacy on heteropatriarchy."
 –**Mihaela Campion**, Clinical licensed psychotherapist and ARCHER Founder (American Romanian Coalition of Human and Equal Rights)

Female Playwrights and Applied Intersectionality in Romanian Theater

In this collection, the author focuses on several contemporary Romanian female playwrights with residencies in Europe and the U.S.: Alexandra Badea, Carmen-Francesca Banciu, Alexa Băcanu, Ana Sorina Corneanu, Mihaela Drăgan, Dr. Cătălina Florina Florescu, Dr. Mihaela Michailov, Dr. Domnica Rădulescu, Saviana Stănescu, and Dr. Elise Wilk.

In their bold works, written by female playwrights who are academics, activists, and performers, we are invited to discover variations in the modus operandi of the dramatic language itself from metaphorical to matter-of-fact approaches. Furthermore, while all these playwrights speak Romanian, they also think and operate in various other languages, such as Romani, German, French, Italian, and American English.

This book facilitates scholars and students to discover contemporary issues related to Romanian society as presented heavily from a feminine angle and to reveal intersectional issues as seen and applied to dramatic characters in a post-communist country from some authors who experienced communism firsthand. The book is also an invitation to reinvent how we teach dramatic literature by offering 20 interactive, exploratory activities.

Cătălina Florina Florescu holds a Ph.D. in Comparative Literature (Medical Humanities) from Purdue University. She teaches undergraduate courses in theater, literature, cinema, and writing at Pace University. She also teaches graduate seminars on communication to international students at Stevens Institute of Technology.

From top to bottom, left to right: Dr. Cătălina Florina Florescu, Mihaela Drăgan, Dr. Mihaela Michailov, Dr. Domnica Rădulescu, Ana Sorina Corneanu; Dr. Elise Wilk, Saviana Stănescu, Alexandra Badea, Carmen-Francesca Banciu, and Alexa Băcanu.

Routledge Advances in Theatre & Performance Studies

This series is our home for cutting-edge, upper-level scholarly studies and edited collections. Considering theatre and performance alongside topics such as religion, politics, gender, race, ecology, and the avant-garde, titles are characterized by dynamic interventions into established subjects and innovative studies on emerging topics.

Genre Transgressions
Dialogues on Tragedy and Comedy
Ramona Mosse and Anna Street

An Actor Survives
Remarks on Stanislavsky
Tomasz Kubikowski

Black Women Centre Stage
Diasporic Solidarity in Contemporary British Theatre
Paola Prieto López

Meaning in the Midst of Performance
Contradictions of Participation
Gareth White

Burning Man
Learning from Heterotopia
Linda Noveroske

For more information about this series, please visit: www.routledge.com/Routledge-Advances-in-Theatre--Performance-Studies/book-series/RATPS

Female Playwrights and Applied Intersectionality in Romanian Theater

Cătălina Florina Florescu

LONDON AND NEW YORK

First published 2024
by Routledge
4 Park Square, Milton Park, Abingdon, Oxon OX14 4RN

and by Routledge
605 Third Avenue, New York, NY 10158

Routledge is an imprint of the Taylor & Francis Group, an informa business.

© 2024 Cătălina Florina Florescu

The right of Cătălina Florina Florescu to be identified as author of this work has been asserted in accordance with sections 77 and 78 of the Copyright, Designs and Patents Act 1988.

All rights reserved. No part of this book may be reprinted or reproduced or utilised in any form or by any electronic, mechanical, or other means, now known or hereafter invented, including photocopying and recording, or in any information storage or retrieval system, without permission in writing from the publishers.

Trademark notice: Product or corporate names may be trademarks or registered trademarks and are used only for identification and explanation without intent to infringe.

British Library Cataloguing-in-Publication Data
A catalogue record for this book is available from the British Library

ISBN: 9780367474140 (hbk)
ISBN: 9780367498535 (pbk)
ISBN: 9781003047711 (ebk)

DOI: 10.4324/9781003047711

Typeset in Times New Roman
by Newgen Publishing UK

Dedicated to all my loves –

and to my *restorative* silences.

Limba română este patria mea –

Romanian is my motherland.

(Nichita Stănescu)

Contents

	Foreword	xiii
	A Note Before Reading This Volume	xvii
1	*Feminin* (Feminine)	1
2	*Pisica Lui Schrödinger* (Schrödinger's Cat)	14
3	*Ein Land Voller Helden* (A Land Full of Heroes)	24
4	*Romacen: Vremea Vrăjitoarei* (Romacene: The Age of the Witch)	37
5	*Pulvérisés* (The Pulverised)	49
6	Moss (*Verde Crud*)	60
7	*Hai Să Vorbim Despre Viață!* (Let's Talk About Life!)	73
8	*Familia Offline* (Offline Family)	83
9	Exile Is My Home (*Exilul Este Casa Mea*)	95

10 Aliens With Extraordinary Skills
 (*Extratereștrii Cu Puteri Supranaturale*) 108

Post Scriptum *119*
Miscellanea *123*
About The Playwrights *125*
Index *128*

Foreword

I started to think about this project as a reaction of my being in the United States since 1998. As an educator, I have noticed, uncountable times, the discrepancy when it comes to what is offered in schools and universities in terms of dramatic literature. Not only are there few writers from Eastern Europe included in the curricula, but the list typically leans towards authors whose body of work has been translated into English – that is, who won awards and/or whose plays were produced professionally. I'd like to clarify that I investigated this discrepancy not with an alarmed, pessimistic reaction, even though that could be justified in this context, but with a desire to make a small gesture of reparation.

When I began to think about this project more consistently, I knew that I wanted to focus exclusively on female playwrights who were born in my country of birth, Romania. One of the reasons why I wanted to focus only on them rather than on writers from the entire region of Eastern Europe stemmed from my being an author from diaspora who wanted to pay tribute to her linguistic and cultural lineage. By writing this book, I had a chance to travel back to my roots, while at the same time to ensure that my identity stays hyphenated and, thus, it transcends my original birthplace.

Furthermore, as a cis, working mother, academic, a person with a neurological condition, and a naturalized woman of the United States, I safeguard my immigration story close to heart. One of the consequences of my multilayered identity relies on issues related to being treated as a foreigner on several fronts. On the job market front, for years, I could not work because I did not have a working visa and I was in the arduous, lengthy process of

being naturalized. Without a job, I was reminded of my immigrant status and work-related inequalities. As a mother without access to a nanny or free day care, for the first three years of my son's life, I stayed with him and, even though I do not regret that decision for a single nanosecond, I still could not help but notice that women who become mothers are not supported by the American legislature so they could have access to more sustainable help and a decent maternity leave. For example, in New Jersey, a child has access to public schools once they turn three years old. When these realities are analyzed together, a third emerges rapidly and it is probably more concerning. This relates to issues stemming and ranging from post-partum depression to mental health. I had to push harder to see the proverbial light at the end of the tunnel, many times knowing it had to be a "monster" if it let itself appear after such a long journey, full of frustrating and repeated episodes for immigrant women like me.

Without any doubt, one of women's dominant features is our long-endured strength. Armed with that, I delved into various readings, watched several documentaries, and read/listened to significant interviews about women of complex backgrounds until I found enough support, as well as validation, not only for this project, but also for my career as an educator and an author. I could write an entire book dedicated only to my role models, but in the interest of staying focused, I would like to express my deepest gratitude to Professor Kimberlé Crenshaw, the pioneering woman behind the revolutionizing term "intersectionality." Coined more than 30 years ago, the concept has managed to become a part of our must-have surviving kit. We are aware of the several injustices and inequities that are done to women worldwide. This word, "intersectionality," talks about systemic, oppressive perspectives, gives credit to our fights and rights, and allows us to breathe. Yes, exactly, you read that correctly! We have been asked to be silent for too long. We have been asked to be submissive for too long. We have been asked to stop questioning for too long. We have been indoctrinated to "breathe" in all sorts of untrue stories about our potential for too long. Under the generous, renewing forces of "intersectionality," we can finally breathe the freedom that we knew for too long existed in us!

All the Romanian female playwrights selected for this volume look into what "intersectionality" means to them and their

Foreword xv

respective careers. One of my ambitions was to select women from different age groups, late twenties to early sixties, and to notice how age could be explored stylistically. Furthermore, I wanted to make sure that some of them still live in Romania, while others live in different parts of the world. The plays selected for this volume address issues related to education in schools (or lack of appropriate, up-to-date curricula); sexual education and the stigma associated with that, especially when shaming women; kids and teens left to manage on their own the intricacies of parenthood with parents who must leave Romania for cheap labor; debilitating poverty and its consequences; LGBTQ and the always elusive, sometimes misleading nature of "traditional families/values"; toxic masculinity; global markets and inhumane working conditions; immigration and its vast intergenerational ramifications; Porajmos, the Roma Holocaust; and others.

Structurally, this volume is unique because it is aimed not at presenting an exhaustive analytical interpretation of these plays, since, frankly, that will invalidate their vast complexity. Instead, I rely on my experience as an educator regarding how (dramatic) literature should be introduced in schools and universities. First and foremost, I want readers to sample from the primary sources with some of my reactions inserted alongside. I also want readers to be so curious that they get in touch with me or the playwrights themselves to request a copy. With very few exceptions, these plays cannot be accessed in the United States, and that is a problem that could be easily fixed. Second, I want to present excerpts from the plays in a bilingual format. We have been invaded by English, and, in doing so, for the most part it has been comforting. We speak a version of English that allows us to communicate. However, when we talk about diversity and inclusion, we must listen to other types of sounds, so that for a second, we are pushed outside of our comfort zone. We could then see how the simple act of listening to or the reading of fragments coming from other linguistic backgrounds will make us respect those literary traditions, as well as invite more authors to this still pretty much exclusive and excluding English table. There, those born into this dominant language could have access to great world literature. Third, I want to give playwrights a chance to answer some questions and thus allow readers to have access to their perspectives on intersectionality, feminism, etc. Rather than repeating the questions in each chapter,

readers are invited to consult the book's Appendix. Fourth, I have been teaching for decades and have developed my own style of engaging with students. I have also been creating several performative workshop series outside of academia and I have been working as a curator for a new play festival for the last five years. Because of all this, I wanted the volume to have an applied dimension, so I have designed exercises/activities for each play, which can be used in classrooms and/or outside of them. I think that we must reform education and my contribution stems from seeing what can be applied directly to literature, what can be used from our personal and/or collective experiences and employed as ways to advance more in-depth dialogues. Fifth, I decided that the best way to introduce these female playwrights had to be unmediated by any outside voices. I wanted to use my hyphenated experience and engage in a genuine dialogue with these plays, characters, themes, and messages.

Finally, I would like to thank the playwrights who have enriched my worldview, granted me free access to their respective plays, and allowed me to use stills from the plays' performances. On a professional level, I would like to thank the editors for granting me a new deadline to submit my manuscript. Due to COVID-19, my brain was caught in a loop that did not allow me to think and write at my own standards. Furthermore, my chronic, debilitating migraines increased their severity, so I had to take even longer than usual breaks from writing. Showing such solidarity helped me tremendously. On a personal level, I would like to thank my family and friends who have been loving me unconditionally and allowed me the space I needed to evolve. Even though I have been living outside of my daily Romanian interactions, every now and then I write and communicate in my mother tongue. I never speak my English with a perfect accent. I am not embarrassed by my accidental place of birth. Instead, I perform it as a woman whose identity is fluid, borderless, and ultimately free.

<div align="right">Hoboken, NJ, 2023</div>

A Note Before Reading This Volume

In 1989, Crenshaw made public her research in an article that revolutionized our ways of looking at discrimination, "Demarginalizing the Intersection of Race and Sex: A Black Feminist Critique of Antidiscrimination Doctrine, Feminist Theory and Antiracist Politics." Ever since that paper was published, we have been introduced to its quintessential parts: that is, discrimination is based on race, sex, gender, status quo, immigration status, differently able body, and thus we have seen the dangers in trivializing equity. Before I present the ten authors' plays selected for my book, I'd like to offer two quotes from the above-mentioned article because they create a common ground when applying the concept of intersectionality for the performing arts and beyond. Needless to say, the article must be read fully, but, for the scope and vision of this volume, I will only share these key passages, leaving the readers in charge to do more.

As Crenshaw says, "According to the dominant view, a discriminator treats all people within a race or sex category similarly. Any significant experiential or statistical variation within this group suggests either that the group is not being discriminated against or that conflicting interests exist which defeat any attempts to bring a common claim. Consequently, one generally cannot combine these categories. Race and sex, moreover, become significant only when they operate to explicitly disadvantage the victims; because the privileging of whiteness or maleness is implicit, it is generally not perceived at all" (151). Given my Medical Humanities background, I read this quote from an interdisciplinary lens thinking about any medical condition, its textbook definition, and its myriad ways of manifesting itself in diagnosed people. Our uniqueness, something that we hear repeatedly when we are young, becomes more

of an unnecessary heated topic as we grow older and want to contribute to the development of our communities on equal footing. Furthermore, identity markers help and hurt us paradoxically. We are proud being born in a certain way; however, when these identity markers stay in our way of earning what we should be earning, then their malicious nature is exposed.

Furthermore, as Crenshaw writes, "It is not necessary to believe that a political consensus to focus on the lives of the most disadvantaged will happen tomorrow in order to recenter discrimination discourse at the intersection. It is enough, for now, that such an effort would encourage us to look beneath the prevailing conceptions of discrimination and to challenge the complacency that accompanies belief in the effectiveness of this framework. By so doing, we may develop language which is critical of the dominant view, and which provides some basis for unifying activity. The goal of this activity should be to facilitate the inclusion of marginalized groups for whom it can be said: '*When they enter, we all enter*'" (161, emphasis mine). I chose this quote because of the time when it was delivered. When the author writes "tomorrow," we must have the context and realize that since that moment more than 30 years have passed. Globally, female citizens are fighting for their rights. It is still not a complete victory.

Finally, on a somewhat fascinating coincidental note, in 1989, when Crenshaw was delivering her paper, my country of birth became dictator-free. After decades of intense degradation, indoctrination, and deprivation of bare minimum living standards, Romania began a democratic life, aligning itself to Western ideals and lifestyles. As presented in this volume, however, democracy is a fragile, sometimes highly capricious being, and a mercurial performer. But, when women are in the spotlight, they demand the public's undivided attention.

1 *Feminin* (Feminine)

Elise Wilk

About the Play

The way women are spoken to and how they are collectively (mis) constructed has stayed almost the same before and after the fall of Nicolae Ceaușescu's dictatorship (1965–1989).[1] If we factor in the many victims of domestic abuse, the intolerance towards the LGBTQ community, the high number of teen pregnancies, the heavily promoted traditional family "values," to name a few serious issues that plague equity in today's Romania, then what we discover in this play is going to reinforce the fundamental need to have access to an adequate education. This is a sine qua non condition for a healthy, long-lasting emancipation. The challenge may be to test how much from what the author expresses theatrically can be clearly transmitted to a *non*-Western audience. Not only that, but they must also use a map to see where Romania is[2] and invite the non-European audiences to discover what lies beneath the distinction between Western and Eastern Europe.[3] Therefore, paralleling current realities in Romania, the adjective *feminin* is applied to women exclusively; if it is used for men, that is said to erroneously imply emasculation. The problem becomes even more enmeshed in a net that is as old and patriarchal as time is because to be *feminin*, to act like that, comes with clear rules and expectations, which Wilk scatters throughout her play. For example, *dacă ești fată, e foarte urât să fumezi/așa a zis profa de bio.*[4] The monosyllabic conjunction "if" must be satisfied to corroborate the condition of being a girl/woman. Without that condition met, one is not a *fată*, and if we had a camera to record this moment and if imagination were employed, then we would see a woman's body being attacked by many aggressive wasps. Hold on to that thought

DOI: 10.4324/9781003047711-1

2 Feminin

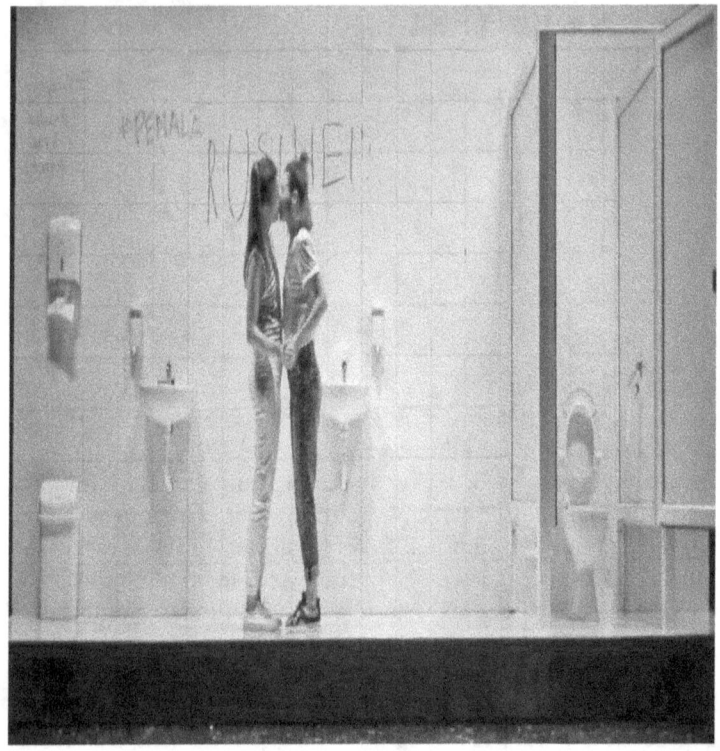

Figure 1.1 Image from performance. Director: Eugen Jebeleanu. Youth Theatre Piatra Neamț, Romania, 2018.

Reproduced with permission from the playwright.

because it is through language that we hurt and caress the most. In other words, if language does not evolve, humans remain caught in the same repetitive acts towards one another and themselves. In antiquity, the Greeks spoke about φάρμακον (*phármakon*), and the power of words to potentially heal and attack. The moment previously mentioned happens early in Wilk's play and it signals the problems that will unfold. The one who makes this statement is a female teacher of biology, the academic subject where students are introduced to anatomy. There, we maintain the binary reality of the reproductive cells: the female sex produces ovules and the male sex

spermatozoa. However, gender is not biological, and Wilk points out how some teachers may misunderstand their pedagogical role, or, worse, make claims that are not corroborated by science. School ends eventually, so these teens may be facing other twisted ideas. If they think that what they learned in school had to be true, then they may have a more challenging task of unlearning the indoctrinated ideas presented in textbooks, class discussions, and the like. The audience is invited to think about what happens not only on stage, but also what happened when they were in school, how/if gender was discussed, and how parents and local leaders/key officials approached the subject. Namely, whatever we learn, is never contained in a subject per se, but, like an organism which is a system of equally important seen and unseen networks, the lessons that we discover in school may have serious repercussions. Furthermore, what we learn in biology is always connected with an evolution of ideas that must always be sustained by scientific discoveries.

We are thus back to language, which we will never ever truly leave throughout this collection. In Wilk's play, what this character tells her daughter reflects outdated concepts that at first may have nothing in common with biology until we realize that, if lessons learned there were connected with Sociology, Psychology, Women's and Gender Studies, the mother might not have said the following: *MAMA: La noi sunt reguli /fără decolteu în v /bluză încheiată până sus /fustă sub genunchi/suntem o companie decentă /sunt respectată.*[5] Once women were asked to join the workforce and broke down the walls to get rid of their controlled domesticity, there was an instant trap ahead. I imagine this moment of liberation almost like a premeditated race. Women are ready and eager to start competing, run, give other meanings to their gorgeous bodies/minds.[6] On your mark, get set, go! For a few meters, everything is fine. Then, a loud sound is heard. Women are trapped since they do not own their bodies publicly. They are restricted. They are told how to speak and what to wear. They are not free, and a partial freedom is tantamount to a Machiavellian control. The part that is even more disturbing is when we realize that women are complacent. The above short quote is uttered by a mother to her teen daughter. In this passage, she confesses that, unlike her daughter, she acts like a "woman." Let me rephrase: she *thinks* she is a "good" woman because she follows rules. What the mother says resonates with /echoes what the biology teacher said in the classroom. Thus,

in enclosed spaces, classrooms, bedrooms, etc., not all discourses are up to date. This is one of the huge changes that the playwright invites us to notice and get involved in changing, pushing ourselves out of the so-called "comfort zone." However, to do that, one must understand that the brain, an otherwise highly mysterious organ, must be retrained to think differently, which requires attention to catching subtleties and denouncing indoctrination.

Moreover, the play does not have any male characters. Yet, ironically, and somewhat painfully, we do feel and hear the patriarchal voice too deeply ingrained in mentalities, language, and attitudes. For example, the fact that women in today's Romania are constantly pressured to get married young and procreate immediately after marriage is a painful patriarchal vestige, which is promoted in the name of "tradition." To the question, "Why do we do things the way we do?", the answers typically revolve around "We were told to do so," "This is what we learned in school," "My (grand) parents taught me this." Point in fact, the play starts with MAMA, who says: *nu mi-am dorit un copil atunci/mi se părea prea devreme/ mai voiam niște timp.*[7] Later in the play, POLIȚISTA adds: *pe urmă vă căsătoriți toate una după alta/oare de ce la toate nunțile lumea spune/așteptăm să venim la botez.*[8] When the two ideas are juxtaposed, the meaning of the adjective *feminin* is expressed as loudly as possible. To be a woman <u>and</u> feminine, one must marry and procreate.

To bring the non-European audience closer to this part of the world, towards the end of a traditional wedding, the godmother takes the bride's veil off her head, and replaces it with a *basma* (i.e., kerchief) because now the bride has become a respected, married woman. There is no equivalent gesture done to a groom, and that speaks volume. Furthermore, because that moment happens publicly, a woman might as well say goodbye to own her dreams. Grounding this next thought in personal experience, whenever I retrieve this moment from my memory, I see invisible but all too heavy chains coming out of nowhere and occupying forcibly the body of the young bride, making her feel like a *good* woman-wife-mother – all at once, preferably said without any pause and care. To make things worse, there were times (and in some villages this is still observed) where the act of confirming a bride became a "respectful" woman happened during the night of the wedding. After being deflowered, as proof of her being a good

girl, the guests and family would dance around with the stained bed sheet.

So, to return to how the play starts, Wilk makes us feel this woman's other aspirations were cut off prematurely by the expectations to be a woman, that is, to become a mother. However, we sense from the start the woman's regrets. If she were given more time to find herself, if in school she was taught better, maybe she would have been more in tune with her mind and body. That condition was not met, so she lives as another replica of the old, good woman trope. Furthermore, Wilk writes her male characters brilliantly into the play. On the one hand, they are invisible. They do not occupy a space on paper or on stage. Yet, they are felt viscerally, and that is a stronger, almost omnipresent menace.

Let's now examine the plot of the play to prove this point. EA (i.e., SHE) is the main character. EA took some naked photos of herself that somehow ended up being shared/reposted on too many phones. EA is about to be kicked out of school. It does not matter that EA is one of the best students. EA should have known better. In the meantime, the one for whom the photos were allegedly taken is not punished. Even though he is non-existent, EL (i.e., HE) did not undress and photograph his naked body. The double standard is key in this moment because we realize that, in a situation like this, female teens are made to be seen as whores, having their bodies/minds objectified harshly. To make us realize the injustice, Wilk introduces a moment where a boy does exactly as he pleases because he knows he can do whatever he wants. During an episode between the protagonist and her aunt, the former confesses: *EA: un tip de la noi din școală/are un cont de instagram/unde pune poze cu fete/le ia de pe contul lor de facebook/ și le pune pe instagram/cu tot felul de statusuri nasoale/ nu vrei să ajungi acolo/crede-mă.*[9] The protagonist is too aware of the negative comments girls receive and, worse, how they are judged by too many rigid eyes at once, how their photos are used without permission, how there is no law to stop and punish that, and how cyberbullying is not taken seriously into consideration. Once a photo is posted on a social platform, one may receive too many negative comments, and this typically happens instantaneously. What SHE tells her aunt is that there is a clear gender divide, and it has gotten worse because of the Internet and the ignorance of not challenging the status quo and old ideas.

This remark is quintessential to make us understand that the female protagonist is not a naïve person, and that what she did, involuntarily or not, may have been to expose the many intersectional problems that still exist in today's Romania. First, she is the second child, who came into this world with an enormous task she didn't ask for, i.e., to "fix" a marriage that did not work. The suggestion here is obvious: with no couple therapy sessions available or with no educated views on how therapy could help, with toxic beliefs related to the "virtues" of traditional families, with women not being able to find a place to stay with their kids post-divorce (*if* they dare to do that), with eyes watching and judging a divorced woman for not being capable to hold on to her man, one has a clearer understanding of the raw first lines of the play.[10] The fact that women are mold to have one shape, that of their vaginas and uteruses, this represents a constant and severe invalidation of their complex potential. Once they become mothers and allow their bodies to go through this major transformation, they are tacitly assigned the role of single parenthood, even though, technically, there are/could be two parents in a household. When the daughter is about to be kicked out of school, her mother laments: *taică-tu ca de obicei /n-are nici o treabă/nu că ar fi avut vreodată /când aveai febră 42/se uita la televizor în camera cealaltă/ eu ți-am schimbat șosete cu oțet toată noaptea/când am chemat salvarea/el deja se culcase/ […] eu îmi dau sufletul/și tot eu pierd în final.*[11] I opted to translate quite literally towards the end to expose this woman's desperation because she has been performing unequally too many hours as a parent, putting her kids first, and, when faced with a polemic situation, she is so depressed, she feels that it was all for nothing.

Women are biologically designed to become mothers and welcome inside our bodies a *union* that develops independently from us, little by little. But biology does not help us explain why some women/mothers think of this role as parents as an opportunity to be rewarded in the years to come. That is, parental *love* should remain unconditional. However, it appears that at least here, it is not. On the one hand, this is not an isolated remark made solely by one woman/mother. The one whose voice is presented in this play echoes decades, if not more, of collective lamentations about motherhood and womanhood. The father in the example sleeps without any care when his daughter is sick. Sometimes he watches

TV. His world is never disturbed. Fearfully, women assume the role of single parenting until that injustice backfires, because no one can do the work of two and not suffer the consequences in the long run. However, what is concerning is the guilt that the mother has towards her daughter. The mother does not say what she should have received in return from her spouse but from her child, because she *worked* as a mother! This awful tactic is a result of not knowing how to confront a problem and stop attacking a target that should not have been attacked in the first place. Mothers feel the enormous pressure of raising kids and sometimes think of this love as a transaction. On the other hand, fathers simply demand respect and submission.

To expose this deep wound, let us look at a different moment in the play where we are invited to taste the *heavy* concept of maternity. The passage has its flaws, in the sense that the author does push some lines to a vague and somewhat dangerous generalization, but its merits should not be overlooked. Wilk speaks about a kind of disappearance that happens in plain view. *POLIȚISTA: pe urmă grupul nostru devine din ce în ce mai mic/ până la urmă [rămânem] 2 sau 3 /celelalte dispar/ [...] mai întâi postează ecografii din care nu se înțelege nimic/pe urmă fotografii cu burți imense pe care cineva a pictat copaci mașini pisici/ pe urmă vine poza obligatorie cu ele cu cearcăne și bonetă verde zâmbind obosite cu nou-născutul în brațe/ pe urmă dispar un timp și din viața virtuală /până când încep să-și posteze una alteia pe wall chestii gen/cel mai greu job din lume 24 din 24 fără concediu și fără plată e jobul de mamă /dau share la pagini gen/ mămicicupitici.ro/ și încep să vorbească doar la plural și cu diminutive [...] Nu mai fac nimic, fiecare zi e la fel /dar e cel mai frumos lucru/aș putea să stau 12 ore la rând să mă uit la el/Hai, faceți și voi un copil /Poate că acum vă e bine așa /dar mai încolo/ce să faceți toată ziua?/E cel mai bun lucru care mi s-a întâmplat/E cea mai mare realizare a mea /Tu nu spui nimic și îți aruncă privirea aia care spune /o să ajungi o babă singură cu 25 de pisici.*[12]

The passage is longer, and it is meant to be *painfully* boring, and to make us want to get out of that room and "save" ourselves; still, Wilk makes us listen carefully. This *disappearance* is different than what has been argued in Medical Humanities studies about someone's social disappearance on account of being cut off from their previous social engagements due to prolonged treatments and/or hospitalization.[13] Wilk cuts deeply into intersectionality

to expose several problems: Why are women pressured to procreate and thus give themselves life (*sic!*) as mothers? When should we discontinue to equate womanhood with motherhood? Once women become mothers, signs of becoming tired are present instantaneously (e.g., easy to severe post-partum depression). Moreover, they appear to convince themselves that this is "their" destiny, that they would get gratification by looking at their babies for hours, when in fact they are knee-deep in denial; they are not paid for their domestic labor, one of which is the huge responsibility of raising a baby without help. They are not prepared to face post-partum adequately, which should be included during pregnancy like sonograms and prenatal vitamins. The passage is about choices, even if that is not what they would love to hear. Cornered by society, the women in the above quote have caged themselves more in a situation that feels like a dead end. In Romania, it is expected that *bunica* (i.e., grandmother) will help a lot, so we see how motherhood is a process of burying a woman's needs that starts almost simultaneously with her giving birth to new life. This cycle must be amended. I will never suggest that mothers and grandmothers should discontinue to discover this facet of their personality; however, to perpetuate the financial discrimination of not paying women for household chores,[14] to refuse to address postpartum as part of the pregnancy experience,[15] and to put all the pressure to fulfill so many domestic roles exclusively on women, that is *sickening*! Women should not (be made to) disappear into motherhood because their repressed emotions would resurface eventually in an even uglier, more damaging ways.

Point in fact, when SHE is admonished by the School Principal, while the male teen is not, there is no one there to have her back. SHE is attacked and no one steps in to help her navigate yet another gender-based discrimination. There is no therapist available then and there, or at least one in her foreseeable future. Worse, she is sent home "to reflect" on what she did. Later in the play, we discover that there was another teen who was pregnant and had an abortion, but the school administration "handled" the situation internally, that is, quietly. Once SHE's naked photos are part of a larger discussion and the press and the police are involved, then the school administration puts on an act and claims that whatever happened was an isolated event. Even when the teen is

given a second chance, that comes before she is forced to write a note to admit that what she did had happened *outside* of school.
DIRECTOAREA: vorbește cu maică-sa/să dea o declarație/în care să scrie negru pe alb /că fotografiile nu au fost făcute în incinta școlii/ PROFESOARA: păi nu e clar / DIRECTOAREA: trebuie să fie și mai clar.[16] This moment which happens towards the end of the play makes it evident that the main concern is not toward the mental and physical health of female students, but toward maintaining a lie and thus continuing to betray them profoundly. This moment is a part of the same cycle of lies the education system perpetuates. For example, earlier in the play, DIRECTOAREA says: *așa te învață la noi în școală/să minți /și să pozezi nud /aici e o instituție de învățământ /există un regulament de conduită /nu putem să-l ignorăm /aici nu e permis așa ceva.*[17] Not only is this a blatant fabrication, but it is also a terrifying reality where teachers and the administration abuse their power, fully aware that there will be no consequences.

It may sound paradoxical, so let us analyze this episode. It is a lie since SHE knows how things unfolded. SHE is coerced to lie, so that the school administration looks good. The lie is not just what SHE is asked to do. The lie is also within the entire system that is not willing to change the curricula and teach kids and teens about sex with maturity and respect for their bodies and lives. Furthermore, the lie is a reality because gender discrimination continues to this day in Romania. As stated before, there is no male character in the play, but their brutal, invasive, omniscient presence is felt profoundly until Wilk breaks this cycle. In a brilliant turn of events, it appears that the naked photos were not for a guy, but for another young woman. In patriarchal Romania, where the church oversteps its role by imposing restrictions, marketed as sinful behavioral acts, where the LGBTQ community is hunted down for allegedly promoting unhealthy lifestyles, before SHE meets her *own* love interest, the protagonist talks with us through an imaginary friend. *PRIETENA IMAGINARĂ: cui i le-ai trimis/ EA: mi-e puțin frică/ dacă-ți spun poate o să ai altă părere despre mine/poate n-o să mai vrei să fii prietena mea/poate n-o să mai apari când te chem/PRIETENA IMAGINARĂ: o să apar mereu când mă chemi/ EA: promiți/ PRIETENA IMAGINARĂ: promit / EA: ok/ești singura /căreia îi spun/le-am trimis /unei fete.Pentru câteva secunde, nimeni nu zice nimic.*[18] The dialogue reveals a fragile,

broken teen who has to find resources within herself to cope with reality. She chose to talk to an imaginary friend. However, this is an old method typically used by very young kids, who are encouraged to soothe their discomfort and confront their fears by talking to such a "friend." The technique implies that this type of friend may never judge them and, in doing so, one basically finds a way of speaking their pain, anxiety, etc.

But SHE is not a child. SHE is a teen in a world in which people are not allowed to or even taught how to talk about their pleasures, bodies, needs without being made to feel ashamed. After this encounter, the play slowly moves towards its end. Wilk makes the main character a winner. SHE decides that the best way to be free is to be uninhibited, however simplistic that may sound. The female protagonist finally summons her strength to meet with the other teen and see where that rendezvous may take them. She realizes that she will never be fully accepted in this society, but she can still choose to be free of its intolerant, hateful attitudes. During the encounter with the other woman, SHE finds out that the one for whom she risked everything was accepted to study in the United States. The news may appear to add to her pain, but the playwright does not choose that path. In fact, Wilk must have created one of the most beautiful endings in any play that I have read in my life: *pentru câteva secunde, nimeni nu zice nimic/ EA: a fost bine să vorbim /CEALALTĂ: o să-mi mai scrii? /EA: vrei să-ți mai scriu? / CEALALTĂ: vreau doar să știu că ești bine / EA: ok așa facem/ CEALALTĂ: și acum/o să mergem de mână până la capătul străzii.*[19] These two young women may not end up together, but they both know and accept their sexual life, and are not afraid to make that choice a public statement. Once they do that, they can enjoy their bodies/minds with pride.

In Their Own Words[20]

The play was commissioned by the Youth Theatre of Piatra Neamț in the beginning of 2018. Director Gianina Cărbunariu invited me to write a play for 12 actresses, given the fact that women are seriously underrepresented on stage. I was free to choose the topic and structure of the play. After meeting the actresses, who were between 28 and 65 years old, I decided to write a story that was inspired by a revenge porn case in a Bucharest college.

I think it's the part called *About Children*. In Romania, once you are over 25, there is a big pressure to become a mother, and that comes from the family and even from close friends. I started to feel this pressure some years ago, and I was feeling bad, trying to avoid friends with children, only to escape the interrogation. It was very painful because, by then, I was married to somebody who didn't want children.

I think that my play does not answer but raises questions. The most rewarding feedback is when somebody tells me: "After the show, I discussed the play with my friends for hours."

It's obviously a feminist play (its title; female-only cast; and the main character is a survivor). I don't believe in militant theatre, but in ideas that are revealed in a subtle way.

I don't write to provoke, and I never think that I compete with men. In today's Romania, the most activist playwrights are women. I never experienced gender discrimination as a playwright, I never thought that a theatre prefers a play written by a man vs. one written by me, and I wasn't paid less because I am a woman. It's also possible to experience positive discrimination. I don't ever want to ask myself: Did I get this award because I deserved it, or because I am a woman? Ultimately, I am feminist without shouting it out loud; I believe in art that is personal, emotional, sincere, art that touches people, and does not teach them how to think.

Once a man told me that I succeeded because of my *foreign* name (I belong to the German minority in Romania) and because I am a woman. *If* he is right, then that's positive intersectionality. Of course, the fact that he told me this may be profoundly misogynistic. We are raised in a patriarchal society and this way of thinking has shaped our views. It will take a long time to get rid of these misconceptions.

Activities

1. In 300 words, think about something that you wanted to happen so badly, but, for reasons outside of your control, it did not. Since you work from memory, which is deeply imbued in subjective, volatile layers, first, try to revisit the moment internally, savor it for a few minutes, and then bring it back to life via an uncensored, free write technique. Read your piece out loud without editing it. Reflect on the opportunity to revisit and

verbalize a moment from your past that did not happen as you had hoped it would.
2. Create a mask onto which write two of the most embarrassing/hurtful words that you have ever experienced in your life. Let the other see and read them out loud. Then, exchange masks. Start a conversation where the aim is not to provide solutions but to listen carefully.

Notes

1. www.britannica.com/biography/Nicolae-Ceausescu
2. https://european-union.europa.eu/principles-countries-history/country-profiles/romania_en
3. The Iron Curtain, www.pbs.org/redfiles/prop/deep/prop_deep_maps.htm
4. If you are a girl, it is disgusting to smoke/the bio teacher told us.
5. MOTHER: Where I work, there are strict and clear rules: no woman wears a V-shaped blouse/the shirt is buttoned way to the top/the skirt is long/we are a decent company/I am given respect.
6. I have a non-Cartesian perspective on our minds and bodies, which I perceive as one.
7. MOTHER: I did not want a child back then/I mean I thought it was too soon/I needed more time.
8. POLICE WOMAN: All of you then get married, one by one./ I just don't get why everybody says at a wedding/We cannot wait to come to the christening.
9. SHE: This guy, you know, from my school/has an Instagram account/and he posts photos with girls/he takes them randomly off of Facebook/and reposts on Insta/and that's not it/he adds nasty comments/you don't want to end up on his page/trust me.
10. Revisit Note # 5.
11. MOTHER: as always, your father could not care any less/I mean, why would I be surprised?/when your temperature was 103 Fahrenheit, he was watching TV in the other room/I was the one who changed your socks and dipped them in vinegar the whole night/your father was long asleep. I sacrificed everything/and yet I lose everything in the end.
12. POLICEWOMAN: then, our group is smaller and smaller/it's maybe just 2 or 3 of us/all the other are gone/ [...] first, they start posting photos from their sonograms and you just don't see what they see/then those images transition to their growing bellies onto which you see what may look like painted cats trees cars/ then ... this is a must... the photo where they hold their babies while they have those dark circles around their eyes/they're tired, but they smile/ they wear a green cap/

then they even disappear from their virtual lives on Facebook/until they reappear/posting comments on a fellow-mother, like/being a mother is the toughest unpaid, nonstop job/start sharing pages after pages devoted to motherhood, like/mămicicupitici.ro/and they start to talk by using the plural form and baby talk/[...] They do not do anything else, their whole days are the same/ they keep saying that this is the best thing that happened to them/that they could spend 12 hours just looking at their babies/ they keep encouraging us to make a baby/ even if now we are happy with our lives/later that would change/they keep saying that we may have things to do now/but later?/That would change/if that's not convincing enough/they say with emphasis/that becoming a mother was their greatest achievement/and what, do we want to become old spinsters with 25 cats?

13 This social phenomenon is analyzed at length in my book, *Transacting Sites of the Liminal Bodily Spaces* (2011).

14 "Redistribute Unpaid Work," www.unwomen.org/en/news/in-focus/csw61/redistribute-unpaid-work

15 Postpartum Depression, Office on Women's Health, www.womenshealth.gov/

16 SCHOOL PRINCIPAL: Talk to the mother/tell her to draft a statement/ to make it clear/that those photos/were not taken in school. TEACHER: Everybody knows that. SCHOOL PRINCIPAL: We need it in writing.

17 SCHOOL PRINCIPAL: Is this what our school teaches you/to lie/to take naked photos/this is an institution where we educate/we have a set of rules/we cannot do as we please/this is a respectable school.

18 IMAGINARY FRIEND: To whom did you send [the photos]?/ SHE: I'm a little bit afraid./If I tell you, maybe you will change your opinion about me/maybe you will stop being my friend/maybe you will not want to come to talk to me. /IMAGINARY FRIEND: You can always count on me./SHE: Do you swear on your pinkie?/IMAGINARY FRIEND: Yes. Pinkie promise./SHE: OK. You are/the only one/who knows the truth:/those photos were for another girl.

19 *[f]or a few seconds, no one says anything.* SHE: It was cool that we finally met. THE OTHER WOMAN: will you write to me? SHE: do you want me to? THE OTHER WOMAN: I want to know you are fine. SHE: OK, I will then. THE OTHER WOMAN: and now/we will walk together holding hands. We will walk like that until the road ends.

20 Vide Appendix.

2 Pisica Lui Schrödinger (Schrödinger's Cat)

Alexa Băcanu

About the Play

Pisica lui Schrödinger takes its title from a famous paradoxical thought experiment where a cat is and is not alive at the same time. The play revolves around the birthday motif, which, in turn unwraps many subplots. As kids, we remember the cake, the song, and the gifts – if lucky. As adults, we are thankful we are healthy – if luckier. For the most part, a birthday is a reason to celebrate and be happy, accompanied by loved ones. Some people question everything, especially near or on their birthdays: their doubt, angst, and loneliness, despite having friends. As LUMI, the protagonist of the play, says: *[m]ă gândesc la viitor, cu multă frică mă gândesc la viitorul apropiat, când voi intra la Sorin în casă și prietenii mei or să urle: La mulți ani! Și eu o să „mă sperii" și o să zic Doamne ce proști sunteți, vreți să fac infarct?* Zic asta știind ce-o să urmeze, știind că vor urma glume despre cât de bătrână sunt, o zic ca să pot să râd tare- maniacal-să-am-ceva-de-făcut, dar corpul meu moare în timpul ăsta de o mie de morți posibile și plânge de o mie de pierderi posibile...[1] While this happens a little bit later in an otherwise short play, it is important to give readers a clue into the main character's split perceptions of her selves: one wears a mask for others and continues to engage with them as it "should," and another does not fully know what's going on with her. After all, as the title indicates, the play is an invitation to look at paradoxes, and thus to be open to life's scenarios, even when they come unexpectedly and make little sense.

Life comes with some blunt certainties: a day starts at dawn, and it ends at dusk; each year we become older on our birthday; at one

Pisica Lui Schrödinger 15

Figure 2.1 Image from performance. Director: Alexandru Berceanu. UnTeatru, Bucharest, 2018.

Reproduced with permission from the playwright.

point, our life ends. In between, we fall in love, discover pain, and eat cake. We can change our name or sex, but we cannot change when we were born. While these statements border on platitude, they are nonetheless important because they anchor our lives. By the same reasoning, some laws have not changed: the law of gravity, or how the universe aims at harmony whereas humans attempt that, too, but do not always succeed. Furthermore, we learn the alphabet, the meaning of certain words, some repeated excessively, while attempting to discover who we are, what we want, and how we feel. Moreover, when trauma is not addressed, it deepens within

one's body/mind. In other words, as Băcanu proves in her play, at any given moment, we are potentially about to be deeply altered by others, our misguided emotions, and/or outside forces. The playwright starts her play with a simple statement uttered by an omniscient narrator or maybe played in voice-over: *La început a fost cuvântul, iar acel cuvânt a fost au.*[2] While at first we may think the playwright talks about an onomatopoeia, the more we read, and the more we get to the play's end, we realize two things: the female protagonist analyzes the concept of pain that we will unavoidably experience as embodied beings. On a very large and provocative scale, Băcanu rewrites the Biblical line where God said, *Fiat lux!* (i.e., Let there be light!). In a bold gesture, the playwright takes the lead and suggests that in the beginning there was something that caused us to react in pain. It is not a minor challenge, mind you. In rewriting that famous beginning, the playwright points to other narratives that could/must be reevaluated and adapted to fit and speak about our female needs.

If in the beginning there was pain, then the author wants us to accept and not fight against it. Conversely, if pain is ignored or ridiculed, it will manifest with possibly worse consequences. When LUMI was a small girl, she was raised in a heteronormative family where the father and the mother had constant fights. *LUMI: Mă trezesc. E încă noapte. Taică-meu urlă la maică-mea în camera de lângă. Îmi pun capul sub pernă.* NARATORUL: *Dacă ți-ai fi lăsat capul sub pernă, dacă ai fi apăsat puternic până începeai să vezi steluțe...*[3] The situation between the mother and the father deteriorates, culminating with the mother leaving the house, taking the daughter with her, and trying and failing to have another relationship with a different man. LUMI is the kind of person who has a difficult moment processing all the terrible bits and pieces around her, and that is not her fault. Therapy could have helped her, but that does not seem to be an option. The awful, verbally abusive experiences kept piling up, invading her body/mind. Thus, it is not surprising to see that an ordinary elevator ride becomes something more terrifying. *LUMI: ...[s]imt că m-am închis într-o piscină cu rechini. Mă ia cu amețeala, mă sprijin de perete până urcă liftul, încerc să-mi fixez privirea pe o crăpătură din podea, dar crăpătura se cască și se învârte.*[4] The playwright creates a piece where she looks at a woman who barely moved from one trauma to another without having the professional evaluation

of a specialist, and a subsequent, customized treatment. This begs the question of how many women hide how they feel, do not learn how to open up, or, worse, how many are not believed, and how personal tragedies are belittled. The more time passes in this state, the more a woman may be unable to feel any joy. The extreme depression that the character experiences is terrifying, and the most disturbing aspect is that she *appears* functional. The playwright alerts to the undetectable harm each of us may hold within ourselves, as well as to invisible conditions that some actively suffer from: *LUMI: ...[m]ă târăsc, mă clatin, transpir, corpul meu nu vrea, corpul meu nu poate.*[5] Since the play is centered around the birthday motif, one of the questions raised by Băcanu is if the protagonist could process the passing of a new year when everything hurts profoundly, yet, for the sake of others, she forces herself to wake up, get off the bed, and continue the day.

Aside from the surprise party her friends threw for her, LUMI receives a call from her mother: *Și acum mă sună mama, seara când a ieșit din tură și poate să se relaxeze sau ce face ea după ce curăță după turiști doișpe ore pe zi, poate bea și ea un pahar de vin, simt plânsul înainte să-și dea chiar și ea seama, undeva pe la mijlocul urărilor, undeva între Dumnezeu și multă sănătate, prietenii mei se uită la ceva pe Youtube și râd, mama mea plânge singură undeva într-o garsonieră din Costa Brava, 30 de ani, zice, ești mare acum, și râde, doar ieri erai o fetiță împiedicată, îmi vine să-i zic că sunt și mare și mică, zic lasă că și acum sunt împiedicată, și mama mea nu mai zice nimic, știu că deja nu se mai gândește la mine, se gândește la vremea când eu eram și o greșeală și o binecuvântare...*[6] The mother–daughter relationship is severely damaged, and neither seems to know how to fix it. They grew apart from the moment when the daughter left with her mom to live with a stepfather until the mother left the country to become a poorly paid worker. The playwright does not give other details about the fractured relationship, but, keeping with the paradoxical vibe of the play, this relationship seems to be good and bad, present and absent, hurtful and soothing. Opposite forces are part of the same whole. As humans, we hope we will experience more pleasant events, but the playwright invites us to examine things and relationships from a more mature, complex perspective. However, when the foundation is shaking, when parents fight a lot, when they separate and the

next environment is anything but supportive, when a mother packs her things and goes, then, to be able to enjoy the simple joys of life may become problematic. For example, *LUMI: E o problemă matematică. Anul ăsta de ziua mea, la ora 14:03, am împlinit exact 870.912.000 secunde. Din secundele astea, când mă gândesc la viața mea, eu îmi amintesc, în total, un minut. Hai să zicem un minut jumate. Momentul când am înțeles că dacă plângi în public, lumea râde de tine. Aveam 4 ani și mă lovisem. Îmi amintesc perfect fața mătușii mele care mă imita în bătaie de joc. Momentul în care nea Nelu, vecinul nostru de la țară, a pus o pisică pe un butuc și a tăiat-o în două cu toporul, pentru că ne mâncase o găină. Momentul în care l-am văzut pe Claudiu culcat într-un sicriu mic, trei zile după ce ne-am jucat pitulușu în spatele blocului. Momentul când tata și-a făcut bagajul și a plecat să trăiască în altă parte. Momentul în care diriga m-a certat în fața clasei pentru că n-am avut bani de fondul școlii Momentul când eu și mama ne-am făcut bagajul și am mers să stăm cu alt tată. Momentul când Ionuț a zis că nimeni nu o să vrea să facă sex cu mine, pentru că n-am țâțe. Momentul când Alex dintr-a șaptea, crush-ul meu, mi-a zis: la ce te uiți, urâto? Momentul când tata nr. 2 mi-a pus mâna pe piept și a zis că încep să crească. Momentul când mama m-a trezit noaptea și am mers să stăm la mătușă-mea. Momentul când a murit Dumbledore. Momentele când mă uitam cu mătușă-mea cum mama stă la coada de securitate de la aeroport. Momentul în care am primit telefonul că bunica a murit. Momentul când tata mi-a dat sms că se însoară. Omul de știință desenează o întreagă schemă matematică, ilustrează ce povestește Lumi. Inițial, credeam că lucrurile se întâmplă așa: aici e trauma 1, da? Apoi trece timpul, ori Timp, trauma 1 se scade din întreg, Î mare, apoi intervine trauma 2, ori Timp, rezultă Î (întreg) minus t2, +t3 și tot așa.*[7]

 This entire passage had to be quoted in full because it offers enough clues to understand that the main character has been in an *unchecked* emotional distress for a very long time. She is using her thirtieth birthday to expose how she did not have closure with her past. This is one of the reasons why she cannot follow the rigid pattern of equating her womanhood with reductive clichés. The fact that there is a professional with whom she can finally interact, that does not mean that that person can help LUMI navigate easily her previously repressed traumas. Moreover, her name can be interpreted as short for *lumină* (i.e., light), or *lumi*

(i.e., plural for worlds). There are many broken worlds inside this character, and none is presented in a detached manner. If anything, she musters the courage to go to the darkest depths of her existence, thus giving herself the long overdue gift of accepting her past. On her thirtieth birthday, she can finally expunge her traumatic past while simultaneously give birth to a new version of herself. Therefore, the birthday motif transforms into a much-needed attempt to address and heal her wounds. Understood that way, then the play is a wakeup call meant to alert readers to make time for themselves, as well as their family members and friends, listen to their (own) stories, and reassure them they are in a safe space.

Still, to add more nuance to this character, LUMI's body is at a point of being broken too severely. First, there is the result of her mammogram. As she says, *Nu mai pot să dorm, deci nu mai pot să mă trezesc, nu mai pot să o iau de la capăt, îmi amintesc tot. Caut soluții, soluțiile au nume fabuloase: diazepam, zolopide, ramelteon, trialzolam, dar corpul meu știe când e păcălit. Într-o dimineață, corpul meu refuză să se mai miște. Șeful așteaptă să-i trimit rapoartele, pisica așteaptă să fie hrănită, mama așteaptă să o sun, doar corpul meu nu mai așteaptă nimic. Mă trezesc cu un tub pe gât. O asistentă e la fereastră, trage jaluzelele. Afară ninge. E și ăsta un moment.*[8] This could be the moment when LUMI may regain control over her life or lose it completely. Whatever happens next should be decisive for her own sake. No one should experience their life in such a permanent state of repressed distress without speaking about their problems for fear of being ridiculed. LUMI is living proof for those women who know something is not right, but, since they have not been believed, they reach a point when they entertain the idea of giving up. However, Băcanu wants LUMI to be free and start her life from scratch knowing that she has finally verbalized her problems publicly. The cat from the famous Schrödinger's thought experiment should finally be out in the open air. If LUMI was the metaphor for that cat this entire time, we cannot ignore *her* presence anymore, and we most certainly cannot be silent about any experiment conducted without consent on her body/mind. Thus, the female protagonist is not satisfied being and *not* being heard and seen but reverses the experiment to exist in the present moment, allowing her vulnerability to be openly validated.

In Their Own Words

The play started as a project with Andreea Chindriş, who took over the administrative part of it. I wanted to write something about depression and anxiety. I wanted to find out more about them, and I wanted to express what they felt like. We had talks with psychologists and focus groups. Since depression and anxiety are not "obvious" diseases, consequently, they are often dismissed, and those affected by them are frequently misunderstood.

I would like readers to leave with an elevated understanding for what other humans go through, but also show more compassion. By ignoring an issue, we only allow it to grow faster and stronger. Talking, reading, and/or writing about it helps. I would like readers to feel less ashamed; having a psychological disorder doesn't make anyone weak, and I hope it's obvious how much the female protagonist fights for her life. I would also like people to educate themselves and thus stop simplifying and confusing these issues with temporary sadness that may pass with a good night's sleep or strong willpower.

What I worry about the most is how to tell a good story, while still transmitting the things I want to say. Feminism is part of who I am, but it's not a "sword;" it's rather "atmospheric." It's imbued in the story without using the concept explicitly. I wanted LUMI to feel true and whole, for both women and men. Also, I want men reading the play to question themselves whenever they are tempted to think euphemistically that women are "mysterious" beings.

What I try to do is to remain very aware of what I write and how it could be perceived by my readers. I stay away from clichés unless I want to analyze or subvert them. I doubt my judgements and try to trace them back to where they came from. I often ask myself: Would I still feel or think like this if I were a man? Or if I had been born somewhere else? Or if I hadn't had the education I had? Which part of me is really me and which is the world's expectation of me? Moreover, after I realized that for the most part of my life all I knew, with very few exceptions, were male artists, I made the choice of consuming more art created by women.

My play speaks about things I care about in a way that is authentically me. I don't know how we could do more than that

except for putting our stories out there: making room for ourselves and for those who are not in a position to do so themselves. As a woman, I really do have all these voices inside my head, just like in *Schrodinger's Cat*, pulling myself in all directions and often contradicting themselves. As a woman *and* a writer, I often shut up the voice that tells me my writing is too poetic or emotional, or worse, too feminine, whatever that may mean. At some point, I had to make a conscious decision to stop equating feminine with bad, and emotions with signs of weakness. We are all weak and we are all strong, even if in different ways, and we need each other and we need to understand there are many, many ways of being, and all of them are valid.

Intersectionality means inclusive feminism. As a white heterosexual woman from a working-class family, I am aware of my privileges, as well as the ways I am discriminated against. I understand there is more than one way of being a woman, or of being human, and no one should be left out. This awareness shapes the stories I write, the questions I ask myself, and the characters I create. I realize that in the U.S. the term "intersectionality" has been discussed for a longer period. In Romania, the conversation has recently started and the heavy part of it, just like in the U.S., is carried by people who are not white or straight. They are the ones, most of all, whose stories need to be included as part of our human experience, and not just as a small, exotic niche.

Activities

1. In 350 words, compose a letter to one of the most influential groups of people from your community. Demand their active involvement in making mental help accessible to all female identified persons. Before you start writing this letter, research why and how women are twice as likely to suffer from depression and trauma compared to men.[9] Additionally, research and/or listen to powerful speeches that brought significant changes, so you have the most persuasive tools available for your own piece. Then, plead with facts/evidence for women's right for therapy.
2. Create a list of two or three activities that are good and bad for you. You can replace activities with people and/or food. Have a polite, relaxed discussion. Reflect on the deeply paradoxical and quixotical nature of our existence.

Notes

1 LUMI: I think about my future, I think about it with a lot of fear, not the distant but the very close future, when I will step into Sorin's apartment, and my friends will shout: Happy Birthday! And I will pretend to act surprised, and I will tease them, Guys, seriously? You almost gave me a heart attack ... I say this because I know what will happen... they will make jokes about how old I am, and I will play along, actually I will laugh so loudly and then look for something to do, to deflect their attention while deep inside I feel I am dying, something is too much to bear, I have no idea why and how I'm dying but I feel I'm losing my mind, my body, everything...
2 In the beginning there was the word, and that word was ouch.
3 LUMI: I wake up. It's still dark outside. My dad yells at my mom. I cover the noise with a pillow over my head. NARATOR: If you buried your head into that pillow, if you had only tried that harder, you could have seen stars...
4 LUMI: I feel as though I am trapped in a pool full of sharks. I feel dizzy, I lean on the wall until the elevator reaches my floor, I try to find a safe spot and look at it with reassurance, but this spot feels like a hole that grows bigger, and I feel even dizzier now.
5 LUMI: I crawl, I shake, I sweat, my body is reluctant to cooperate, my body just can't...
6 LUMI: It's late, my mother finally has a spare moment to call me. She is a maid who cleans for 12 hours, and I feel her heartache before she even notices it, but she masks it under all her greetings and blessings and tosses a glass of wine to my health. In the other room, my friends watched something on YouTube and laugh, my mother cries in a studio apartment in Costa Brava, 30 years old, you are so big now, and starts to laugh recollecting when I was a child, how I used to stumble, I feel like telling her, I am big and small, and yes, I do still stumble, but I don't say anything because I feel my mom is too tired to continue the conversation, her mind drifted apart someplace else, or maybe she thinks back when I was a blessing and a curse...
7 LUMI: It's a math problem. This year, on my birthday, at 2:03 pm precisely I turned... . 870.912.000 seconds. It's funny, because out of all these seconds, when I truly but I mean truly reflect on my life, what I recollect from it, all that I can honestly retrieve does not last more than one minute. Fine, fine, a minute and a half. That moment when I realized that if I cry in public, people'd laugh at me. I was 4 years old, and I fell. I remember vividly my aunt's face who was mocking me. That moment when "uncle" Nelu, we call him that way, but he was

our neighbor, really, killed a cat so viciously with an ax because the cat ate a chicken. That moment when I saw Claudiu for the last time, resting his tiny body inside that tiny coffin, and only three days before we were playing together. That moment when dad packed his things and went to live someplace else. That moment when my homeroom teacher scolded me in front of everyone because I forgot to pay my membership. That moment when my mother and I packed our things and went to live with a different daddy. That moment when Ionuț told me no one would want to have sex with me because I didn't have boobs. That moment when my 7th grade crush told me to stop staring at him. That moment when my new "daddy" felt my breasts and reassured me I would have boobs soon. That moment when my mother woke me up in the middle of the night to say that we would be living over our aunt's place. That moment when Dumbledore died. That moment when I was looking at my aunt who was waiting in line at the airport's security check-up desk. That moment when I got the call that grandma died. That moment when my dad told me via a text message that he would remarry. SCIENCE MAN draws a very complicated diagram, illustrating all the inner worlds of our characters. Back when I was innocent, I thought everything could be reduced to an equation. For example, things happen and result in a trauma, that's the start. Then, time passes. Then, time erases trauma, but after that, boom, a second trauma, then some more time passes, and it just goes on and on and on and nobody can find an answer.

8 LUMI: I have trouble sleeping, and if I can't sleep, I can't wake up, I can't restart my life, in fact, I remember everything. I seek solutions and all have fantastic names: diazepam, zolopide, ramelteon, trialzolam, but my body knows they will not fix my problems. One morning, my body decides it's too much and does not want to move. My boss is waiting on me to send him the reports, my cat waits on me to be fed, my mom waits on me to be called, and the only one that does not want anything from me anymore is my own body. I woke up intubated. A nurse pulls the drapes up. It's snowing. That moment when it has started to snow...

9 Gender gap depression: https://mindsetsd.com/why-women-are-more-prone-to-depression/

3 *Ein Land Voller Helden* (A Land Full of Heroes)

Carmen-Francesca Banciu

About the Play

Banciu is the senior playwright included in this project and this statement matters to me because she is a passionate writer and activist. After the Romanian Revolution of 1989, she managed to get a scholarship to pursue her writing in Berlin. It was a one-year deal, however, Banciu has been living there ever since. In 2000, she published an autobiographical novel, *Ein Land Voller Helden*,[1] where she narrated her journey from Romania to Germany, and how the past in her native country made her choose to become one of its many "uprooted" citizens. She adapted her novel to be performed and what resulted can be described as a hybrid, docu-theater, mixed with lyrical moments. Not only are those who participated in this revolutionary event sent on a trip back to the *hot* year of 1989 when the entire communist bloc revolted against their political, long-endured nightmare as a consequence of how the world had been divided post-WWII, but readers are also invited to see how intergenerational trauma is manifested internally. In other words, the premise of the play qua journey that retraces the steps Banciu did decades ago gives us a taste of how manipulative the communist regime was, how her own father, a devout communist acted and did not pay attention to the needs of his daughter, and how, to survive, she retreated into her own universe, (re)creating worlds.

Moreover, what we discover is the mechanism of surviving, and it becomes evident why the female author made her choice to stay and work in Berlin post-1989. Banciu disputes – or at least deeply interrogates – what she refers to as a "European identity."[2]

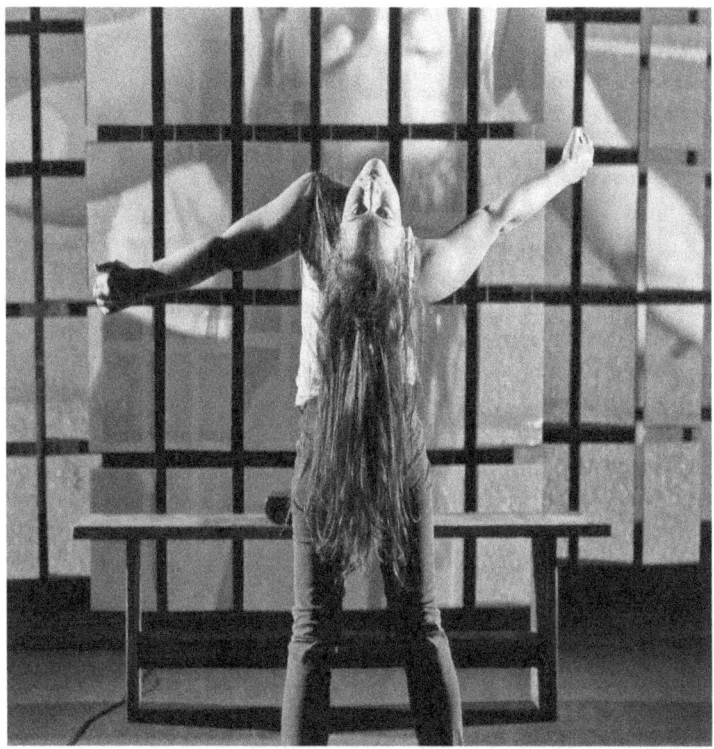

Figure 3.1 Image from performance. Director: Carles F. Giua. Birmingham Repertory Theatre, Birmingham, UK, 2019.

Reproduced with permission from the playwright.

The structure of the play has several "Documentation" parts where things are not spoken but presented in voice-over (V.O.), and projections interspersed with bits of dialogue. The adaptation starts quite abruptly, but that is an excellent choice since political persecution is severe, traumatic, and sudden. While most of us do not believe in ghosts, nonetheless, we should never deny that the past could manifest itself as nightmares, no matter how far or distant we are physically from a place of birth that denied us the right to live there freely. Envisioned as stage directions, we are introduced to the following: *Heute, am 15.*

Oktober 2018 kommen wir gerade in Bukarest an, wo wir unsere Dokumentationsreise beginnen werden. Wir bereiten unser viertes Dokumentarfilmprojekt vor, das auf den Erfahrungen von Carmen-Francesca Banciu basiert. Eine Rumänische Schriftstellerin, die in Berlin lebt und arbeitet. Die Idee dieser Reise ist es, die Reise von Carmen-Francesca zwischen Bukarest und Berlin nachzubilden kurz nach der rumänischen Revolution Anfang 1990. Wir werden mehr als 2.000 Kilometer fahren, wir sind am Anfang der Reise, Wir sind jetzt ungefähr 30 Kilometer gefahren. ...Es ist der 16. Oktober und wir sind in Sarmizegetusa³ ... oder was davon übrig ist. Es ist eine archäologische Stätte, die die Ruinen verschiedener Tempel des Dakischen Königreichs umfasst. der Name, der Rumänien in der Antike gegeben wurde, Das Königreich, das zu Beginn des zweiten Jahrhunderts von Kaiser Trajans Legionen besetzt wurde. Es ist wahr, dass es keinen direkten Zusammenhang mit der Erfahrung von Carmen-Francesca Banciu gibt aber es hängt mit der Geschichte zusammen und wie ein Reich durch ein anderes ersetzt wird. Ich meine das Gold, das Gold, das die Römer mitgenommen haben, um das berühmte Trajan-Forum in Rom zu bauen.[4] This may appear as a lengthy quote, however it is crucial for readers to realize that, despite witnessing an autobiographical piece, this is more than that since one human being is never fully complete on their own but a part of a moving/movable history. From the start, one question is how/if we could make history more visible; and how we should teach those from Western Europe that being reduced to follow orders, being kept in the dark for far too long, is akin to a powerful physical wound. So, if we meditate on the vast ramifications of this quote, we can then begin to perceive history differently. Between 101–102 and 105–106, the Dacians,[5] the original population in what we now know to be Romania, were invaded by the Romans in the latter's expansion for land and resources; however, the victors took whatever they wanted from these parts of the world while referring to the Dacians as being barbaric and inferior. This is not something that happened only "back" then in history. This is how we still see narratives of displacement being introduced in mass-media, where some are portrayed erroneously as superior nations and/or superpowers, while others struggle while being exploited and abused by the former. In other words, the former's self-proclaimed success has more likely been secured by subduing the other's resources. These

repeated abuses should serve as a reminder to always *question* why some nations are more advanced than others. Furthermore, during the next scene in Banciu's play, the author introduces an alter ego to continue her narrative goals. Despite freedom manifesting itself in her former country of birth, time has not healed her wounds, so, we meet the playwright as herself and MARIA MARIA. Because the script has no clear indications regarding who the characters are, we are left to assume the latter is whatever the author experienced personally; for example, being followed and intimidated by *Securitate* (i.e., the Romanian Secret Police). The author dives into interrogation immediately after the play's stage directions. Banciu creates a disembodied experience to protect herself and to teach us that sometimes it may help to have an alias who may shield us, or someone whom we can use as a scapegoat. The author lets herself become a character whom she investigates in a very metatheatrical manner. The interrogation scene is not only done by officials, but also scrutinized by her mature self. We are introduced with a concept that circulated last century heavily until we realized its flaws, and that is "the human of the new era." Whatever MARIA MARIA wanted as a child and teen, her wishes were denied: *Maria Maria lebt in einem modernen Haus mit vielen anderen Familien von Parteifunktionären. Es ist ein sehr modernes Gebäude, aber es gibt dort keinen Platz für Schönheit. Nur einmal betrat die Schönheit das Haus von Maria Marias. Einmal kaufte ihre Mutter Plastikblumen. 'Sie sind sehr gut, weil Sie sie nicht gießen müssen' und Vater sagte: 'Warum werfen Sie unser Geld aus dem Fenster?' Es gibt keinen Platz für Musik. Es war verboten, in Maria Marias Haus zu singen. Einmal kam ihr Vater zu ihrer Schule, nur um die Lehrer zu bitten, ihr nicht zu erlauben, zu singen. Sie trägt immer Kleidung, die zu klein für sie ist. Sie ist nie auf dem neuesten Stand. Es ist eine Besessenheit der Mutter, sie nicht attraktiv aussehen zu lassen. Maria Maria mag ihren Blick nicht (wir sehen eine Nahaufnahme von Meda wie in einem Spiegel), aber Frauen müssen sich gegen Männer verteidigen. Dies ist eine Welt, die von Männern regiert wird. Maria Maria hat sehr schöne Augen. Sie hat einen sehr geraden Blick, schaut nie nach unten. Sie ist sowohl emotional als auch analytisch. Sie beobachtet, sie versucht Menschen zu verstehen. Wenn sie eine Musik wäre ... [wir hören eine leise, leise Musik ...] ja, sie könnte diese Musik sein ... Sie ist mutig, selbst wenn sie Angst hat. Ja ... Angst. Seit*

ihrer Kindheit hat sie das Gefühl, dass es etwas Seltsames gibt, etwas wie einen Schatten, der ihr folgt. Sie erzählte dieses Gefühl ihrem Vater. Aber es war ihm egal. Es gibt Dinge, die wichtiger sind: Party. Opfern. Kollektiv. Heimat. Der Mensch der neuen Ära.[6]

We become a part of this character's past where she was denied enjoying the arts, discovering her beauty and intellect, and, consequently, she noticed a *shadow* following her constantly. She is clearly not interested in whatever is promoted in her household and society. This vision of "the human of the new era" is a pale version of someone who is joyless and robotic. MARIA MARIA exposes her highly introspective nature because those who ask questions, who interrogate themselves and others, and who react to propaganda and its brainwashing techniques will (at least) stir something inside themselves.

When Banciu starts to write her novel about two young communists from different parts of Europe, the authorities begin to follow her relentlessly. Unlike her father, the narrator is not a follower of the communist regime. Worse, she may become an "enemy" of the state. Unintentionally, she may introduce stark differences between two European lifestyles and, thus, the *utopic* "human of the new era" would become void, exposed mercilessly, and possibly even ridiculed. Therefore, fearing the potential disaster of the ironically exploitive tools of free writing, authorities must act now to silence this character's otherwise solemn intentions: *INTERROGATOR: Sie schreiben einen Roman. Worum geht es? (Wir hören einige Männerstimmen, die die Stimme von Carmen Francesca überlappen.) MARIA MARIA.: Es geht um die Reform des Kommunismus. Es ist ein Dialog zwischen zwei jungen Kommunisten: Einer aus dem Osten, der andere aus dem Westen. INTERROGATOR: Sind Sie kritisch mit unserem System? MARIA MARIA: Kritisch? INTERROGATOR: Vielleicht denken Sie, dass der Westen besser ist? MARIA MARIA: Das habe ich nicht gesagt. INTERROGATOR: "Ich bin stolz auf mein Land, wir bauen eine neue Gesellschaft auf, eine, die es vorher noch nicht gab, aber wir sind immer noch weit vom Kommunismus entfernt. " Dies steht in Ihrem Brief vom 14. März 1972. Was genau meinen Sie mit dieser Passage? MARIA MARIA: Ich meine, der Kommunismus ist ein gutes System, aber wir sind noch weit von großen Errungenschaften entfernt. INTERROGATOR: Wollen Sie*

unsere Gesellschaft verunglimpfen? MARIA MARIA: Ich sagte, dass ich stolz auf mein Land bin. INTERROGATOR: Sie wollten eine Demonstration organisieren. MARIA MARIA.: (Schweigen) Wer... INTERROGATOR: Vielleicht ein Mitglied Ihrer Familie. Vielleicht ein Klassenkamerad von dir. Warum hast du eine Demonstration geplant? MARIA MARIA:... die Partei ist sich der schlechten Situation der Menschen auf dem Land nicht bewusst... INTERROGATOR: Sie kämpfen gegen Ungerechtigkeit. MARIA MARIA: Ich versuche es. INTERROGATOR: Weil Sie ein guter Kamerad sind. MARIA MARIA: Ja, das bin ich! INTERROGATOR: Vor zwei Jahren haben Sie sich geweigert, mit uns zusammenzuarbeiten. MARIA MARIA: Ich weigere mich, meine Kollegen auszuspionieren. INTERROGATOR: Möchten Sie reisen? MARIA MARIA: Wer will die Welt nicht sehen. INTERROGATOR: Vielleicht möchten Sie in einem anderen Land leben ...MARIA MARIA: Warum sollte ich? INTERROGATOR: Sie haben viele Brieffreunde. Auf der ganzen Welt. Italien. VEREINIGTES KÖNIGREICH. Österreich. Deutschland. MARIA MARIA: Auf keinen Fall. Ich möchte meinem Land helfen, einer der besten Orte für uns alle zu werden.[7]

The interrogators do not have time to listen to and record her story, but assault her with incriminating questions so that she may crack under pressure and admit to believing ideas she does not really follow. No one who was interrogated by *Securitate* ever felt that they were in a room to be believed, quite the opposite. Needless to say, their tactics relied on coercive intimidation.

For those who were not in such an invasive and intimidating situation, I can feel MARIA MARIA's lost innocence. When I was 14 years old, I was interrogated twice by *Securitate*. Only in retrospect, could I seize how well trained an interrogator was, what that person wanted to hear, how my words were manipulated, how sickening I still feel to this day, even if too many years passed, how that "bad" taste could not be removed, and yet how this experienced nightmare must be made public. This personal note aside, MARIA MARIA thinks that if she answers honestly, that would be it, and she could leave. This is when the *dramatized* version of the author steps in: *INTERROGATOR: Warte hier. MARIA MARIA.: Ich kann nicht gehen? CARMEN FRANCESCA: Nein, das kannst du nicht. Du mußt warten. Ich werde Ihnen sagen, was passieren wird. Sie werden hier sein und wieder stundenlang warten.*

Und danach werden sie kommen und sagen: Du sollst morgen zurückkommen. Und morgen wird es dasselbe sein, mehr Briefe, mehr Zitate. Und morgen und morgen. Acht Stunden am Tag. Für einen Monat, zwei Monate, drei Monate ...Und danach werden sie deine Eltern zu den Schlussfolgerungen einladen. Die Vernehmer werden sagen, dass sie Ihre Qualitäten schätzen, aber dass Sie zu stark vom Westen beeinflusst sind, dass Sie Ihre Einstellung ändern müssen, um für sie wertvoll zu werden, dass Sie zusammenarbeiten sollten. Aber Sie sagen "Nein", Sie werden nicht zusammenarbeiten. Und dein Vater wird in Schwierigkeiten geraten. Ihr Vater wird aus seiner Position entlassen, dies ist das Ende seiner Karriere als Beamter der Kommunistischen Partei. Und dein Vater wird dir das niemals verzeihen. (Stille.) CARMEN FRANCESCA: Und Ihre Hände werden viele, viele Jahre später wieder schwitzen, wenn Sie an diese drei Männer denken. Wir hören die Musik ihre Lautstärke erhöhen, nach einigen Sekunden aufgenommene Stimmen. Sind Sie kritisch mit unserem System?Bist du ein guter Kamerad?Hast du einen Freund?Sie haben eine Datei. Verunglimpfen Sie unsere Gesellschaft?Bist du schuldig. Was sind Sie bereit für Ihr Land zu tun?Ist dein Vater korrupt?Denkst du, du bist schlauer als wir?Was meinst du mit Freiheit?[8]

When you've read the English translation, attempt to answer some questions. Respond on the spot and time your reaction to *30 seconds*. One should not pause indefinitely to think because that could not be a sign of understanding a question and formulating an answer, but, in their twisted universe, a clear proof of betrayal. It sounds surreal, and yet it was so painfully true! Then, go back to the interrogation scene and reanalyze it. This is a young woman who is questioned in a room by a person who wants to hear *his* truth, or, even better, the "truth" of the Communist Party. The young woman has no moral support then and there, or after. When CARMEN FRANCESCA comes in the room, MARIA MARIA is introduced to *reality*, which is a tough wakeup call. The interrogation is far from being over. However, this is also one of the reasons why she can teach her kids to be more aware of the potential of being spied on. Equally important, this is one of the reasons why she wants to leave her country of birth. The revolution happened in 1989. She gets a grant the year after. Romania is free. But the author does not want to live there anymore. She needs a fresh start in a city that, ironically, experienced a lot of

collective trauma on account of a *wall* erected for no other reason except to divide two sides of the *same* city, thus changing people's histories irrevocably. The wall that once separated east from west Berlin is the author's reminder of permanent scars that we wear on our body/mind. Her experience in communism and her decision to leave Romania secures her feminine outer skin fiercely.

The mother–daughter relationship is another opportunity to accurately inform her child. We must remind those who never experienced what we had endured that, when we were growing up, we could not express our opinions, we did not have nutritious meals, and our present and future were not ours at all. We should do this because there are individuals who *believe* atrocities that some people experienced were not real, did not happen, and *are* coercing inventions. The rise of "fake news" is something that we must consciously check so that history and people's traumatic past is not ridiculed and denied. Seeing MEDA, one of Banciu's daughters developed into a character, going through phases of denial vis-à-vis her *own* mother's lived stories and how she will be confronted by reality are impactful ways to engage an audience who did not experience this reality on their own. Intersectionality-wise, the protagonist's experiences as a woman, mother, and writer, who decides that she must leave Romania to find a better future for her family, touch upon uncountable similar examples where mothers realized the danger of living in a society that refused making profound changes. Nonetheless, all this comes as a sacrifice; that is, living as an immigrant is always a traumatic experience because now that individual must fit someplace else, must prove they are valuable to become citizens of their new country, must live in two worlds of then and now, and are frequently visited again and again by one overwhelming question: Was it worth it?

Furthermore, when the author reminisces about the death of her father, at the funeral, there is a RAVEN whose presence is symbolic: "You wrote about heroes. But heroes are people ready to sacrifice for a cause. You don't know anything about heroes. Nothing." To me, this character is a pale version of a communist ideal where all people "were" equal and owned the same as everyone else. However, that was a utopic dream at best. While in 1989 the Iron Curtain fell, the ghosts of this imposed division are felt to this day. For example, the play ends with a confession that ties us back to a

quixotic "European identity." The dramatized version of the playwright returns to say the following: "When I arrived at Tempelhof, I did not know yet that I will remain in Berlin. Maria-Maria is my character closest to myself. I gave her most of my life experience, my thoughts, questions, hopes, and fears. In Berlin I continued to develop her. I needed her to help me evolve. To recognize Berlin as a metaphor of our time. To discover freedom. To understand what is the right thing to do, when you leave your country, after the collapse of a dictatorship. After a revolution. Soon I recognized that Berlin was the place I was looking for. It was the city where two political systems grew together and annihilated each other. And a new world, a new society, a new system was supposed to develop out of them. I wanted to learn from my past and from the emerging present. I wanted not only to be a witness. I wanted to participate, to become a part of it." Banciu needs to breathe in a new air. However, as a person born in Europe, she belongs to *any* country she chooses. Or, as she says, "[w]hen we crossed the Austrian border, things finally changed. Finally, variety and heterogeneity appeared. The colours were more intense, the air was cleaner… In Dieter's house, I remember his mother, an old and small woman while she was watering the flowers. I remember her small and thin hands. I remember her care, her delicate behaviour… she took out the dry leaves and petals. It was like a prayer."

She can now observe and experience any details of an ordinary life and see how she did not have access to it before because she had to constantly be on the lookout to protect her life. That is hardly a life fully lived. Thus, when we talk about a European identity, we realize that it lacks equity, that people from certain countries are still not *invited* to join the European Union because they have to "prove" themselves. In other words, to have such an identity, one must see the map of the continent with mature, objective eyes, and instead of waiting for an official letter of acceptance, proudly and loudly *continuing* their belonging.

In Their Own Words

My play focuses on the December 1989 Romanian Revolution, communism, and my flight to Germany. I wanted to understand myself and help others understand what happened to us during

communism. I believe knowledge of the communist experience is essential for the current social development worldwide. I also wanted to explore the intertwining of the political and the private realms under dictatorships and how it expresses itself within family relationships.

The play is largely based on my experience processed literarily, but it is at the same time a part of a collective experience that has brought about great changes and is, therefore, beyond a personal framework. Still, I think I would choose the part when my character, MARIA MARIA, who lives under terrible conditions with her family (comprised of a husband, children, and a dog) in a one-room apartment during the communist era, refuses to see herself as a victim and does not want to flee the country, but instead teaches her children foreign languages and makes plans for a future freedom.

I want to give the audience insight into the dynamics of family and social-political dictatorship. I hope to encourage them to look at news, events, and experiences from multiple perspectives and always ask themselves who could benefit from this and who could exploit it. I would like to sensitize the audience to help them recognize manipulation, to take personal responsibility, and to practice resilience.

Women must leave the role of victim behind and take part in society on an equal footing. Those who value their own abilities, recognize their birthright to equality and act accordingly will find their place in life easier. It's a sheer transformational process.

The experience of the writer/narrator and this character, MARIA MARIA, are framed by a video that documents the journey of the stage director and the set designer/video artist. Two men follow the story of the life of a woman, the author. They want to explore her former environment, understand, and document her life and literary work. In doing so, they themselves go through a transformational process during which they discover an interest in Romania, Eastern Europe, old and new kinds of borders and fences. They open up to the feminine points of view and are ready to learn new things.

I experience different kinds of discrimination. Positive discrimination, too. Most of the time, however, it is negative or covert discrimination. I was born and raised in Romania. As an author,

I wrote my first book in Romanian. But I wrote the rest of my books in German because I have lived in Germany for 30 years. In Germany, I am considered a *Romanian* author, and in Romania, a German one. I see myself as transnational.

Activities

1. Following the author's advice according to which women must "[l]eave the role of victim behind and take part in society on an equal footing," interview two female-identifying members of your family/community, and ask them to talk about a similar moment when they made a clear choice of exiting victimhood. End your piece with a reflection: What have you learned? Why is it important to know the past of your family/community members? Now, define victimhood.
2. Research as many details as you can possibly find about Sarmizegetusa. Create a monologue in which a female character talks about the preservation of monuments, yet how the excavation of truths may "upset" ill-informed/manly manipulated realities.

Notes

1 Adapted into English by the author in collaboration with La Conquesta del Pol Sud.
2 "Is There a European Identity?" https://globalcenters.columbia.edu/news/event-recap-european-identity
3 Sometimes referred to as "the Romanian Stonehenge," Sarmizegetusa is a UNESCO World Heritage Site: www.uncover-romania.com/attractions/unesco-heritage-romania/sarmizegetusa-regia/
4 Today it's October 15, 2018, we just arrived in Bucharest where we will start our documentation trip. We are preparing our fourth documentary project based on the experience of Carmen-Francesca Banciu, a Romanian female writer who lives and works in Berlin. The idea of this trip is to recreate the journey Carmen-Francesca made en route to Berlin from Bucharest shortly after the Romanian Revolution at the beginning of 1990. We will drive more than 2,000 kilometres; we are at the beginning of the trip, we drove now about 30 kilometres. ... It's October 16, and we are in Sarmizegetusa... or what is left of it. It's an archaeological site that includes the ruins of different temples of the Dacian Kingdom, the name given to Romania in ancient times, the

Kingdom that was invaded at the beginning of the second century by Roman Emperor Trajan's legions. It's true that there is no direct link with what Carmen-Francesca Banciu experienced; nonetheless, it's related to history and how an empire is replaced by another. I mean the gold, the gold that Romans took away to build the famous Trajan's Forum in Rome.
5 About Dacians' history: https://study.com/academy/lesson/dacians-history-kingdom-facts.html
6 Maria Maria lives in a modern house with many other families of Party functionaries. It is a very modern building, but there is no place for beauty there. Only once beauty entered Maria Maria's house. Once, her mother bought some plastic flowers. "They are very good because you do not have to water them" and father said: "Why do you throw our money out of the window?" There is no place for music either. It was forbidden to sing in Maria Maria's house. Once her father came to school to forbid her teachers to allow his daughter to sing. She always wears clothes too small for her body. She is never allowed to know the trends. It's her mother's obsession to deny her daughter to look attractive. Maria Maria doesn't like her look (*We see a close up of Meda, like in a mirror*), but women have to defend themselves from men. This is a world ruled by men. Maria Maria has very beautiful eyes. She has a very straight gaze, never looks down. She is both emotional and analytical. She observes, she tries to understand people. If she were a music... (*We hear a low, soft music...*) Yes, she could be that music... She is courageous, even when she feels fear. Yes, ... fear. Ever since her childhood, she has been feeling that there is something eerie, something like a shadow following her. She confessed this feeling to her father. But he didn't care. There are more important things, like the Party. Or collective sacrifice. Homeland. The human of the new era.
7 INTERROGATOR: You are writing a novel. What is it about? (*We hear some male voices overlapping the voice of Carmen Francesca.*) MARIA MARIA: It's about reforming communism. It is a dialogue between two young communists: One from the East, the other from the West. INTERROGATOR: Are you critical with our system? MARIA MARIA: Critical? INTERROGATOR: Maybe you think that the West is better? MARIA MARIA: I haven't said that. INTERROGATOR: "I am proud of my country, we are building a new society, one that has not existed before, but we are still far from communism." This is in your letter from the 14th of March 1972. What exactly do you mean with this passage? MARIA MARIA: I mean that communism is a good system, but that we are still far from great achievements. INTERROGATOR: Do you want to denigrate our society? MARIA MARIA: I said that I'm proud of my country. INTERROGATOR: You

planned to organize a demonstration. MARIA MARIA: (*Silence*) Who...INTERROGATOR: Maybe a member of your family. Maybe a classmate of you. Why did you plan a demonstration? MARIA MARIA: ... the party is not aware about the bad situation of people from the countryside... INTERROGATOR: You fight against injustice. MARIA MARIA: I try to. INTERROGATOR: Because you are a good comrade. MARIA MARIA: Yes, I am! INTERROGATOR: Two years ago, you refused to collaborate with us. MARIA MARIA: I refused to spy on my colleagues. INTERROGATOR: Would you like to travel? MARIA MARIA: Who does not want to see the world? INTERROGATOR: Maybe you want to live in another country... MARIA MARIA: Why should I? INTERROGATOR: You have many penfriends. All around the world. Italy. UK. Austria. Germany. MARIA MARIA: Definitively not. I want to help my country become one of the best places there is for all of us.

8 INTERROGATOR: Wait here. MARIA MARIA: I can't leave? CARMEN FRANCESCA: No, you can't. You have to wait. I'm going to tell you what will happen. You'll be here, waiting for hours again. And after that they will come and they will say: you are ordered to come back tomorrow. And tomorrow will be the same, more letters, more questions. And tomorrow and tomorrow. Eight hours a day. For one month, two months, three months... And after that, they will invite your parents for the conclusions. The interrogators will say that they appreciate your qualities, but that you are too influenced by the West, that you need to change your attitude in order to become valuable for them, that you should collaborate. But you say "no," you won't collaborate. And your father will get in trouble. Your father will be released from his position, this will be the end of his career as an official of the Communist Party. And your father won't ever forgive you for that. (*Silence.*) CARMEN FRANCESCA: And your hands will sweat again many, many years after. (*We hear the music increasing its volume, after some seconds, recorded voices.*) Are you critical of our system? Are you a good comrade? Do you have a boyfriend? You have a file. Do you denigrate our society? Are you guilty? What are you ready to do for your country? Is your father corrupt? Do you think that you are smarter than us? What do you mean when you say freedom?

9 "Why the Berlin Wall Rose, and How It Fell?": www.nationalgeographic.com/history/article/why-berlin-wall-built-fell

4 Romacen: Vremea Vrăjitoarei (Romacene: The Age of the Witch)

Mihaela Drăgan

About the Play

Drăgan is an actress and an activist, and because of her combined roles and personal background, she discovered a huge lack of Roma[1] representation in Romanian literature. She has decided to use her research and personally experienced discrimination in her plays, in which she has many roles: actress, playwright, and producer. *Romacen: Vremea Vrăjitoarei*[2] appears to be a sci-fi dramatic work in which all the characters are witches. But to me, it is more than that. It educates on the extermination of Roma people during WWII, a violence rarely discussed and/or even acknowledged when we talk about the Holocaust. Her play is thus layered, and I will use it to point out to several injustices that are still occurring when we talk about this group of people who do not have a country of their own and are scattered all over the world. The premise of the play starts from something that appears silly, but analyzed more closely, it exposes our servitude for the so-called "great powers" of the world, which, over the course of our recorded humanity, have exploited their dominance over others quite shamelessly.

The play starts with "Operation: Hacking BREXIT" where a newcomer has been invited to join the women's group. From the start there is a feminine energy reminiscent of the old, matriarchal societies. According to stage directions, the first lines are said to be like a curse where all techno-witches participate in an incantation that is somewhat evocative of the old Greek choruses. Drăgan uses a quote from Sir Arthur C. Clark: "*Orice technologie avansată nu se deosebește de magie.*"[3] If we try to decode why she uses this

DOI: 10.4324/9781003047711-4

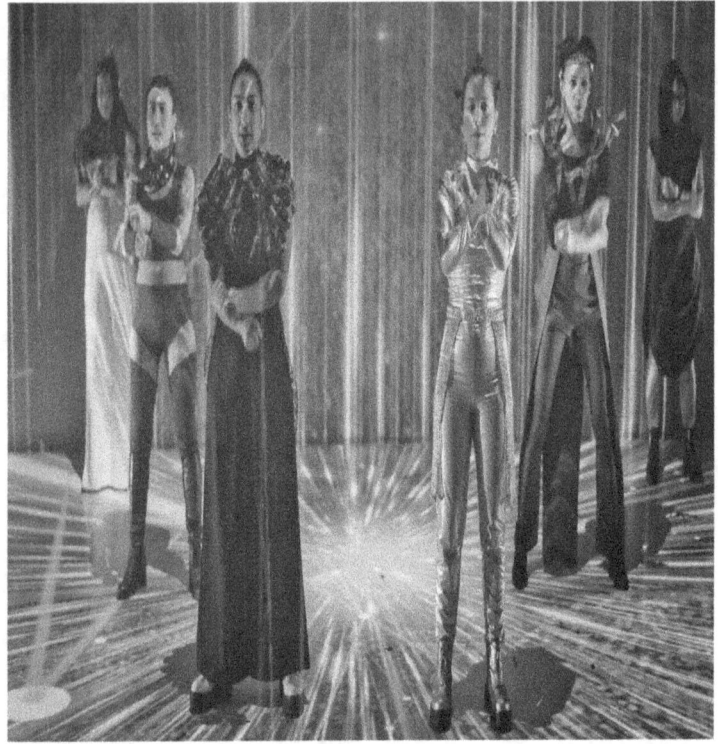

Figure 4.1 Image from performance. Director: Tina Turnheim. Andrei Muresanu Theatre, Sfântu Gheorghe, Romania, 2019.

Reproduced with permission from the playwright.

quote in the beginning of her play, then we understand that, if people do not have any adverse thoughts and reactions towards technology, if they do not view it as having a negative impact on our actions, rewiring our brain to become more and more addicted to its powers, then why is magic viewed *differently*? Moreover, why is it viewed any less than science? By extension, if AI engineers could somewhat manipulate our "inputs," affecting our choices, if neuroscientists attempt to learn more about our brain so we can control it better, then why are magicians and techno-witches viewed in a discriminating light? Who benefits from this misleading

hierarchy and why does it exist? What Drăgan proposes is that we must change narratives to make room for the ones whom we keep excluding, or we keep using as scapegoats. Once we have this frame of reference in mind, we are dragged to face reality and revisit it in such a way that we must make changes. BREXIT is going to be secondary at best as readers delve deeper and deeper into the text. Once the witches are done with the curse qua chorus, the play begins: *PHURI: Numai noi deţineam secretele tuturor meşteşugurilor din lume. CASSANDRA: Fierăritul, ursăritul, căldărăritul... NEVI-CARMEN: Făceam linguri şi oale care rezistau generaţii şi nimeni nu se pricepea să le facă la fel de bine ca noi. DAJE: Eh, mă rog, şi apoi a venit IKEA şi alte corporaţii să le facă ei: fast-oale fără pic de calitate şi să îi lase pe ai noştri fără muncă. KALI2000: Uite de asta urăsc capitalismul. CASSANDRA: Ştiam să prelucrăm aurul şi ne numeam rudari, dresam urşi şi eram ursari.PHURI: După aceleaşi reguli ca ale magiei, am făcut din tehnologie un alt meşteşug aşa cum în trecut numai noi ştiam. CASSANDRA: Dar de data asta nimeni nu o să ni-l fure. PHURI: Ştiţi de ce sunt mândră că sunt din neam de vrăjitoare? DAJE: Pentru că e singurul care a fost denumit după meşteşugul femeilor. NEVI-CARMEN: Acum ştim să inventăm şi să controlăm tehnologia şi ne numim... TOATE: Tehno-vrăjitoare.*[4] We realize that these women are not only a part of a group that has a matriarchal structure, but that they also try to make sure that whatever they do or are about to do will never be taken away from them, that is, *stolen*. This is a very loaded statement because many refer to Roma using a slur, *ţigani* (i.e., gypsies) who are almost invariably labeled as robbers. Worse, when a *gajde* (i.e., a non-Roma) steals, that person did something that only a *ţigan* would have done, thus, again and again, making all Roma people feel like they are worthless, profiling them to fit one stereotypical narrative. From the start, Drăgan reminds us of the Roma's jobs in society and how easily we have disposed of their hard work.

After this exposition, we welcome a newcomer, who is 19 years old, a hacker expert and a rapper. *RAMONA: Sunt foarte onorată să fiu aici cu voi/O societate feministă declară război/Cea mai mare bucurie e de a face parte/Alături de voi din futurista societate/Sunt copil de imigrant stabilit în Anglia,/Nu voi lăsa Brexit-ul să-mi fută familia/De trei ani mă tot zbat cu acest proiect,/"Hacking Brexit" vă face la intellect/Virusul meu i-a infectat/Patriarhatul s-a încheiat/*

Antropecenul s-a terminat/La Romacen să îi dăm start/Epoca Vrăjitoarei de fapt![5] If we look more closely at the passage, certain words stand out, such as "feminist society," "immigrant" and "witch." They are relevant because the main purpose of hacking is not only to derail BREXIT, that would be a small victory, but also to disintegrate the systemic, intersectional injustices. They are Roma, women, and one of them, RAMONA, is someone who does not live in her country of birth, adding to her trauma the condition of being displaced. Furthermore, if we have reached a phase where only witches can save women, then that says a lot about humanity!

Still, these women want to offer alternatives to what was presented in history textbooks, literature, and society. History is not exactly what we were told – a series of past events, but a present, living reality that must be understood accordingly, so that *ura istorică* (i.e., historic hatred) towards Roma people will be forever eradicated. As KALI2000 says: *Istoria se poate schimba constant în evenimente alternative.*[6] Let us unpack this: an accurate textbook on the Holocaust will not only focus on the extermination of the Jews, but also on the Roma people, the LGBTQ individuals, and the differently abled humans. In this scenario, these women's plan is to go back in time, more exactly before the Roma people are going to be exterminated on August 2, 1944, and infiltrate new people there, inside the "Gypsy camp."[7] As KALI2000 adds, *Planul e să infiltrez 10 Oameni Noi în lagăr imediat după momentul de rezistență al romilor ca să-i apere la noul termen de exterminare. Fără să simtă foamea, Oamenilor Noi o să le fie ușor în lagăr.*[8] The tension between the witches is going to escalate because, in part, some seem to disagree with the plan, in part because they are afraid that their action may cause more harm to an already deeply intergenerationally hurt group of people. *KALI2000: În noaptea de 2 august, la noul termen de lichidare, Oamenii Noi o să îi învingă pe naziști. PHURI: Ok. Să zicem că rezistă și la planul de exterminare din august. Ca să ce? Ca să mai trăiască chinuiți până când? RAMONA: Până în ianuarie 1945 când Armata Roșie eliberează lagărul. KALI2000: Repede te-ai prins! PHURI: Intenția naziștilor era să elibereze lagărul ca să facă loc pentru evreii deportați din Ungaria așa că nu i-ar mai fi ținut niciun moment pe romi acolo. WTF, sunt singura de aici care știe istorie? KALI2000: Oamenii Noi o să le împiedice și planul ăsta! DAJE: (o*

imită persiflând-o) Oamenii Noi, Oamenii Noi! (nervoasă) M-ai futut la cap cu oamenii tăi noi care by the way sunt fucking roboţi, nu oameni! În lagăr, oamenii se topeau pe picioare de la o zi la alta, nu exista nici cea mai mică certitudine că o să supravieţuiască până în ianuarie. PHURI: Adevărul e că e un plan nebunesc să încerci să salvezi câteva sute de oameni când nu ştii dacă de fapt tocmai moartea nu ar fi o salvare pentru ei! Încă trei luni de viaţă aşa ar fi un iad! DAJE: Toată Europa e din ce în ce mai fascistă iar noi facem planuri să schimbăm trecutul! Mişto, ce să zic![9] In addition to the already known survivor's guilt,[10] Drăgan talks about where we are "right" now in history, and she invites us to imagine a triage room in an imaginary hospital's ER where we must think whom to save first. Bluntly, we go back in time to save the Roma people from the Nazi concentration camps or try to intervene in the present and make sure fascist tendencies are eliminated.

Drăgan wants to do the former because only by so doing, the Roma people may not be constantly viewed through the same racist perspective as a part of this perpetuated "historic hatred." The playwright could be pursuing a selfless quest; truth be admitted, this hatred is rooted in a more distant past than the one exposed via WWII, an aspect Drăgan does not fully explore in her play. This does not inherently change the play's relevance because I'd argue that what Drăgan wants to achieve is to make sure we do not get lost trying to find the "roots" of this hatred, but instead reflect maturely on the most devastating moment, the Holocaust, and think about restorative tools from that moment onward. For example, CASSANDRA brings to our attention aspects that happen currently in schools, media, and real life. She finds that one of the reasons why people still persist in being openly and carelessly racists is because of what they are exposed to, namely, the books that they read, the popular songs where the word "gypsy" is performed "playfully" to match the tune, etc.: *CASSANDRA (face zoom pe cartea pe care se poate citi "Disperarea" şi e reprezentativă pentru Holocaustul Romilor): Ai parte de o provocare. Acesta este o carte care reprezintă emoţiile, care ar putea să-ţi spună cum te simţi tu sau cele dragi. Persoane din jurul tău vor avea nevoie disperată de ajutorul tău. (face zoom pe cartea pe care se poate citi "Boier" şi reprezintă o imagine din perioada sclaviei romilor în Ţările Române): Dar tu nu trebuie să uiţi că există o autoritate în faţa căreia trebuie să răspunzi. Uită-te bine la cărţile tale: Această*

carte te reprezintă pe tine sau pe cineva pe care cunoști? Simți că ești limitată sau redusă la tăcere ori tu nu lași pe cineva să spună adevărul? (face zoom pe cartea pe care se poate citi "Conversație" și reprezintă doi bunici romi cu spatele unul la cealaltă): În curând primești o sentință, nu pentru acest proces ci pentru întreaga ta viață. Ajungi la un sfârșit.[11]

The women reach an important moment in their journey which could be viewed as sacrificial to a certain extent. Some do not want to go back to the real world. They hope that whatever they may find in this alternative universe is less toxic than reality itself. Very evocatively, the second act is named *Dezvrăjirea vrăjitoarelor* (i.e., The Unravelling)[12] which could signal how difficult it is to fix the accumulated damage and, more, how resourceful the "system" is that all it wants to restore is the triggering *silence*, continuing the abuse towards the Roma people. This second act introduces a new character, the interrogator, who appears only as V.O.; this character represents the system's abuse which pressures women to feel as if they did something wrong. This manipulation technique is so frequently used, that it feels normalized. These women are pressured to admit "their" guilt, even if that is not accurate. The biggest issue is that one of them did not return from her virtual quest. RAMONA is still caught inside her own hacking, and the interrogator fears that, ironically, she could harm severely an unjust system. After a search, RAMONA is found in a state of cryptobiosis. *VOCEA: Calofira Fieraru [Ramona] a fost găsită într-un apartament din Wood Green într-o stare de criptobioză. Deși testele au arătat că nu există nicio daună la nivel cerebral, toate funcțiile vitale îi sunt reduse la minim. Creierul nu îi este afectat în timp ce corpul e într-o stare de sănătate deteriorată. Pentru că nu poate să se miște, să vorbească, să mănânce sau să răspundă oricărui stimul exterior, este hrănită artificial și ținută în viață la un spital al cărui nume nu îl putem dezvălui din motive de securitate. Va fi judecată în lipsa prezenței sale fizice.*[13]

Since the condition does not apply to humans, then, I'd assume Drăgan pushes a situation to an extreme to show that, even if something is not named or is not theoretically applicable to humans, that does not mean that the pain and shame do not somehow emerge. RAMONA is temporarily not functional, which points to a repeated cycle of abuse encountered too many times. Let us remember that she is only 19 years old and that she has been

Romacen: Vremea Vrăjitoarei 43

singled out her entire life. Earlier in the play, RAMONA shared the reasons why she became so attracted to virtual reality: *[c]ând eram mică îmi era frică de întuneric. Într-o zi mi-am dat seama că sursa fricii mele nu era în afara mea, ci în interior așa că m-am lăsat complet absorbită de întuneric. Știam că pot să devin vrăjitoare dacă învăț să folosesc întunericul care locuiește în mine. În plus, eram bullied la școală așa că internetul a devenit cel mai bun prieten al meu, am pus primul meu hack la 12 ani.*[14] To complicate things, we discover that KALI2000 cannot be found at all. We find out that she has managed to find a way to avoid returning to reality. The question that remains is the following: Should the other women do the same since it is clear that they cannot be *accepted* for who they are in real life? *DAJE: Asta înainte să știm că aici vom fi prinse și închise pentru 20 de ani. PHURI: Adevărul e că nu e cea mai bună societate pe care am construit-o dar e cu siguranță mult mai bună decât viitorul care ne așteaptă aici. CASSANDRA: Mai bună decât celula găunoasă în care o să stăm 20 de ani. NEVI-CARMEN: Pe bune? Asta facem acum? Ne resemnăm și noi? DAJE: Nu și tu. Ție nu o să-ți răpească decât 2 ani din viață. PHURI: Nu credeam că voi spune asta dar mi-e dor de Romacen. DAJE: Nu vreau să mi se degradeze corpul. Mă sperie toată povestea asta.*[15] The women decide to choose their own reality, far away from the existent, unfavorable one. Is this gesture sacrificial? Not really, because they give up this world, that is, they do not want to waste another minute hoping for a long overdue reparation. Put differently, why should that even happen, why would they need a miracle to end their intersectional trauma? If this is their last resort, then the only thing that is proven is that they never mattered. *NEVI-CARMEN: La dracu' cu Brexit! La dracu' rasismul! La dracu' misoginia! La dracu' aspirațiile! (pauză) La dracu' teatru!*[16] The playwright sends an unapologetically strong message: we cannot hope that writing plays on this subject will change attitudes *unless* we apologize for the "historic hatred" and proceed on implementing legal amends so that racism is punished as a hate crime.

The play ends with a rap performed in tandem by KALI2000 and RAMONA:[17] *Khere na mai si khere/Si te pakies man/Duriares tut e ceacimastar/Kana na mai dikhes o kham/Kado sundal na-i pakivalo/ Nashliom karing o Romacem/Kerdiam amenqe iekh nevo sundal/ Kodoleske kathe mudarden amen/[...]/Tha ka keras iekh godisardo drom/Te akhiaren vi tume i dukh/Kerau iekh drabaripen ai vazdau*

me poghia/Atoska saore rasisturea meren e pharravde ilendar [...]/ O holipen kai ciudes opre-amende si sar o bumerangos/Irinel opre tumende ai ashti mudarel tumen/Anau manqe godi sar makhliom mo mui/Te kerau man parni sorso somas iekh ciorni rromni/So mishto sas, so lokhorres athardiom tut/Paruvdiom mirri rang/Pala so, tume linen man/Tha vakiardiom zorales ai shukar amaro ceacipen/Atoska phenden manqe:/Ja avri andar amaro sundal![...]/Te astaras o Romacem/Ceaces, o Drabarimasko Vaht/Ka amboldas amen/ Ka amboldas amen / Ka amboldas amen.[18] Drăgan envisions a world where Roma women will use their force to advance their needs, will not apply cream foundation on their skin to pass as white women, will make the other feel their pain, and will not be victims anymore. Drăgan does not want to leave these women repeating the mistake of asking others for help. She knows that only Roma women should stand up and re-claim what is theirs: Romani craft, beauty, songs, clothes, and, above all, dignity.

In Their Own Words

There were many ideas that inspired me: it was the association between witchcraft as an empowering tool for women's liberation and technology seen as magic but belonging to and created by white men. It was also the personal need of knowing that there is possible to have Roma communities prevailing in the future. I got inspired by Afro Futurism and I created my own concept of Roma Futurism. Women, witches, future, robots, the climate crisis, the European politics, history, all these were an inspiration.

"Killing Time Experiment" is one of my favorite parts because it is a scene in which the characters, Techno Witches, who control science and technology, are negotiating over the possibility of returning to the past of their ancestors, victims of the Holocaust, in order to change history. They explore the idea of how Roma communities would have developed themselves without a history of oppression and imagine visions for shaping a future.

I want them to know that we, Roma people, have a plan for the future. That we are not only victims, after all this oppressive history, but we can also be in control of our destiny as a community and world politics. We are thinking about feasible politics of fighting climate crisis, we have an alternative and a political vision

against fascist societies that exclude us, and our identity is not only painful but also proud and joyful.

The main topic of the play is the creation of a feminist antiracist society of Roma women based on solidarity. The name of their society is *Phenjalipen* (i.e., Sorority, in Romani language) and their safe space is called Romacene (a new age that is following Anthropocene and it is controlled by Roma). They try to create a utopian society led by women and sometimes they fail because they internalize and duplicate the same structures of a heteropatriarchal, racist systems in which we all live. When they become conscious of this, there is a turn of the whole narrative.

My play envisions a whole world in which women have the power. There is no male character in the play, no topic in which the female characters discuss men other than criticizing the patriarchy. The women in the play envision an egalitarian world based on their own feminist principles and aim to empower women. A play written by a woman that can become a show only with female characters, directed by a woman, serves as a platform for changing the art world structures dominated by white men.

I am a queer Roma woman, and I cannot be anything else but an intersectional feminist. There is no feminism without antiracism and without supporting LGBT. This intersection is my starting point in the process of writing any play. I write about who I am, but I avoid being personal or exposing my own intimate stories. I create fiction because paradoxically it is the best way to represent reality.

Activities

1. Research the Romani genocide and craft a speech demanding this notion to be introduced in all history textbooks. Make sure that your piece touches on ethos, pathos, and logos, so that your 500-word speech may be succinct, yet effective. Invite Roma people to be a part of this dialogue, so their voices are enhanced civically, and their accounts presented from their first-hand experience.
2. Is "history written by the victors" as we have been taught? Challenge the statement by creating a piece of Invisible Theater which should take place in a setting like Judy Chicago's (1939–)

The Dinner Party where you bring an artifact rarely promoted in art history textbooks and museums.

Notes

1 Roma people: www.britannica.com/topic/Rom
2 Translated by Cristina Cătălina. Commissioned by the English Stage Company for The Royal Court Theatre's International Residency, July 2019. Additional revisions by Camelia Oana.
3 "Any sufficiently advanced technology is indistinguishable from magic," a quote from Arthur C. Clarke's 1962 book *Profiles of the Future: An Inquiry into the Limits of the Possible.*
4 PHURI: We alone possessed the secrets of all worldly crafts. CASSANDRA: Blacksmithing, bear-training, metalworking... NEVI-CARMEN: We made spoons and pots that lasted entire generations, and no one else made them as good. RAMONA: Then IKEA and others came along to take over: making instant pots, not an ounce of quality, leaving our people unemployed.
KALI2000: That's why I hate capitalism. CASSANDRA: We knew how to craft gold and we used to call ourselves goldsmiths, we'd train bears and call ourselves bear-trainers. PHURI: Using the rules of magic and our know-how of yore, we developed the craft of technology. CASSANDRA: No one will steal it from us this time. PHURI: Do you know why I'm proud to have the blood of a witch? DAJE: Because our kinship is the only one taking its name after a woman's craft. NEVI-CARMEN: Now we know how to invent and control technology and we call ourselves... ALL: Techno-witches!
5 RAMONA: I'm honored to be with you on this floor/As your feminist society declares war/It brings me utmost happiness to belong/ To a futurist society alongside you so strong/In England I am an immigrant's child/I won't let Brexit screw my family wild/For three years I've been struggling with this project/"Hacking Brexit" will mess with their intellect/My virus has left them infected/The patriarchal rule ended/The Anthropocene is erased/Romacene–let's press start /The Age of the Witch in fact!/The Age of the Witch in fact!
6 KALI2000: History can be changed constantly if alternative events are introduced.
7 What Is Porajmos? www.romarchive.eu/en/voices-of-the-victims/genocide-holocaust-porajmos-samudaripen/
8 KALI 2000: The plan is to infiltrate 10 New People in the concentration camps so when they are about to be ambushed, they could help Roma. Since they just joined this place, they have resources.
9 KALI2000: On August 2nd, more are scheduled to be exterminated during the night, and that's when the New Humans will register their

Romacen: Vremea Vrăjitoarei 47

first victory over the Nazis. PHURI: OK. Let's say that our people defeat the odds of being exterminated. Then, what? Why are they spared, so that they would have miserable lives? RAMONA: Until January 1945 when the Red Cross steps in. KALI2000: You are smart! PHURI: The Nazis wanted to free that camp so Jewish people from Hungary would be stationed there. So, they had no intention of accommodating Roma people. WTF, am I the only one here who knows history? KALI2000: The New People will deter this plan, too! DAJE (*mockingly*): The New People, the New People! (*angry*) You drove us crazy with all this shit, and just so you know, these are not people, these are robots! Those concentration camps were places to kill people slowly, but kill them nonetheless, so there is no certainty that anyone could survive until January. PHURI: You know what's ironic? To save people without factoring in that life might still be a horrible experience, whereas death could mean salvation! Three more months like this would be hell! DAJE: Europe is becoming more and more fascist, and we are here to change the ... past. I mean, that's crazy!

10 "Survivor's Guilt: A Cognitive Approach" by Hannah Murray, Yasmin Pethania, and Evelina Medin: www.ncbi.nlm.nih.gov/pmc/articles/PMC7611691/

11 CASSANDRA: (*Zooms on a book where we can read "Desperation" and it is representative for the Romani Holocaust*): This is a provocation. This is a book that talks about your emotions, how you should feel them. Your community would desperately need your help. (*Zooms on a book where we could read "Owner" and it shows an image during the slave period in Wallachia*): But please keep in mind that there is an authority that you must obey. Take an attentive look here. Does this book represent you or someone you know? Do you feel being silenced, or do you feel like you don't allow someone to speak up? (*Zooms on a book where we could read "Conversation" and we could see two Roma grandparents not facing each other*): Soon, you are going to receive a sentence. Not for this trial, but for your entire life. You reach an end.

12 The first thing that immediately came to my mind was the Salem witch trials. "Were Any 'Witches' Burned at Salem?" by Owen Jarus: www.livescience.com/how-salem-witches-were-executed

13 VOICE: Calofira Fieraru was found cryptobiotic in a flat in Wood Green. Although tests have shown no brain damage, all her vital functions were reduced to a minimum. Her brain has not been affected, but the rest of her body is in a very bad state. As she's unable to move, talk, eat or reply to any external stimuli, she is being artificially fed and kept alive in a hospital we can't name for security reasons. She will be tried *in absentia*.

14 RAMONA: When I was a little girl, I was really scared by darkness. One day I realized that the source of my fear was not on the outside, it

was within me. I knew I could become a witch if I learned how to use that darkness. Also, I was bullied in school, so the Internet became my best friend. My first hack was at 12.
15 DAJE: This happened before we knew that we would be caught and sentenced to serve 20 years in prison. PHURI: Truth be told, this is not the best society we created, but it is superior to any future awaiting us mercilessly. CASSANDRA: Way better than the tiny prison cell that awaits us. NEVI-CARMEN: Really? This is what we do these days? We too give up? DAJE: Come on! You will spend two years here. PHURI: Never have I ever thought to say this, but I miss Romacene. DAJE: I do not want to feel pain. This whole story is so viscerally unsettling.
16 NEVI-CARMEN: Fuck Brexit! Fuck racism! Fuck misogyny! Fuck your expectations! (*pause*) Fuck theatre!
17 While the playwright gave me her play in Romanian and English, with Drăgan's permission, I asked Dr. Delia Grigore from University of Bucharest to translate this fragment in Romani.
18 Home isn't home anymore/Believe me when I say so/It tears you up from reality/When the sun you can no longer see./This world isn't fair by far/We follow a new guiding star/So I escaped to Romacene/ A new world for us to convene in./Even here the fascists are yielding their power. We build a new plan, we're not gonna cower/Make sure you feel the pain as well/I don't care any more, I cast my spell/And whack, all the racists have a heart attack./Your hatred towards us is like a boomerang/It returns, bites your head off, and bang/I recall using whiteface/To brighten up any streetwise Roma trace/How well, how easily you were fooled/I changed my skin/And you welcomed me in/ Then I hit you with discourse and radical sobriety/And you answered by banishing me from society./Romacene, let's press start/The Age of the Witch in fact/I promise you we'll be back/Hear me say this: We'll be back.

5 *Pulvérisés* (The Pulverised)

Alexandra Badea

About the Play

Some scholars argue that the concept of globalization is as old as the voyage of Cristopher Columbus in the New World in the fifteenth century, in which case, we could see more clearly why globalization and postcolonialism share exploitative features. This chapter introduces a play written by Badea, who was born in Romania but has been living in France for more than two decades. *Pulvérisés* is a severe critique against the widely spread phenomenon known as globalization seen from the perspective of increased human mobility. However, before I discuss Badea's main points qua theater for social change, allow me a threefold digression.

When my son was younger, I took him to a playground in Bucharest. He knew of Beyblade toys with which he was playing in the house by himself, or with a friend, and on rare occasions with me. It was funny and sad at the same time to encounter a group of kids who were playing with the then very popular toy. There I was, visiting my country of birth, hoping to introduce my son to local games (reminiscent of my own childhood) when reality unfolded in front of my eyes differently. My son could connect instantly with those kids and even teach them a few English words and expressions. But I wanted the exact opposite to happen. I wanted him to learn games and words in Romanian. Second, one day I entered a H&M clothing store, trying to find a breezy summer dress. When I came to Romania a few weeks later, I passed by one of its stores only to discover the same products – a shocking and upsetting uniformity. Third, growing up, I used to wear a uniform

50 Pulvérisés

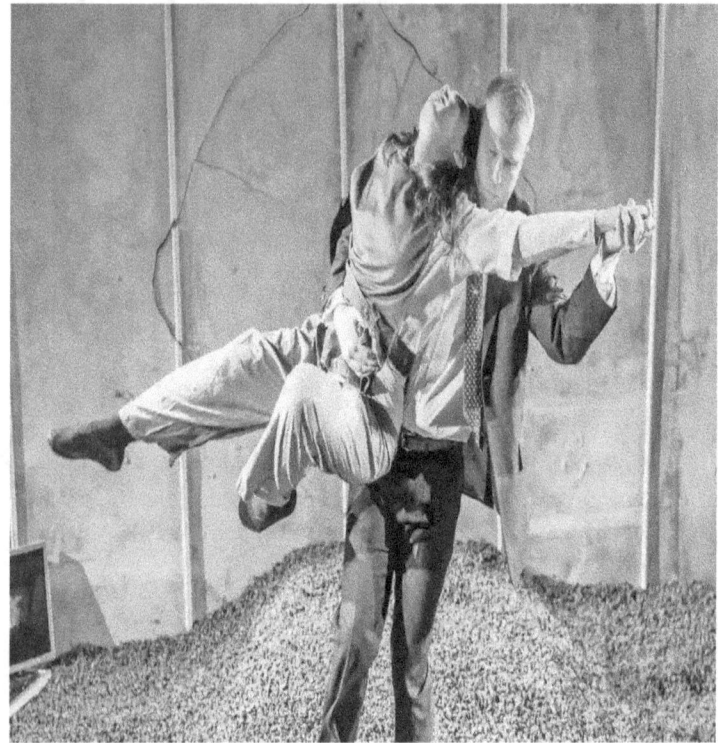

Figure 5.1 Image from performance. Director: Andy Sava. Arcola Theatre, London, UK, 2017.

Reproduced with permission from the playwright.

during the school year. After 1989, it was liberating to dress differently in school, although it took us some time to adjust to that because our wardrobes were quite modest and the concept definitely new.

I wanted to list these three examples before analyzing Badea's play because what's in the script is a clear reflection of reality. Badea does not invent worlds in *Pulvérisés*, but instead talks about the damaging side-effects of globalization. Alongside her characters, we travel to Lyon (France), Dakar (Senegal), Shanghai (China), and Bucharest (Romania), and we seem to be effortlessly

on three continents, Europe, Asia, and Africa; we appear to be visiting four different countries, when, in reality, we will be in *one suffocating* dimension, and in one symbolic "country" where people work without stops, have regimented lifestyles, and move towards (self-)induced "pulverization."

From the start, there is a visceral scene which appears to be happening in Lyon where a male character says: *Tu ouvres les yeux/Paupières lourdes/Ton corps glisse sur le drap/Contraction du grand adducteur/Spasme multiple du triceps /Sécheresse de la muqueuse buccale/Tu ouvres les yeux et tu les refermes/Agression de l'environnement/L'odeur du lit ne t'appartient pas/Rien ne t'appartient ici/Même pas les allumettes, les bouteilles de whiskey en plastique, les cotons tige, les pantoufles jetables ou la cire à chaussure/tu es pulvérisé dans l'espace/Tu es hors du temps paumé entre des latitudes et des longitudes qui s'embrouillent dans ta tête: Delhi, Tokyo, Dakar, Sao Paolo, Kiev, Hong Kong, Santiago// Tu ouvres les yeux/Tu t'accroches à ton oreiller et tu cherches/ Pendant quelques secondes tu es incapable de te situer sur ta carte géographique intérieure/Tu fermes les yeux.*[1] Badea does a remarkable thing in this opening scene because she lets this character become a part of our body/mind by inviting us to evaluate if our existential working condition is similar or not. The unnamed character is in Lyon experiencing an extreme state of exhaustion. The opening and closing of the eyes is more than the physical act of letting the body do its routine moves. Moreover, we get the clear taste of what it means to be alienated, removed from the familiar, and the humane. By scanning the room, the character discovers that nothing in that temporary space belongs to and connects with him. Just like that, we are *pulverized* in a realm that does not seem intriguing, full of potential and adventure, but maddening, debilitating, and already irreversible. What this character needs is a stable point. As the character says: *Il est 2.37 chez toi, là où tu te trouves en ce moment de ta vie entre deux avions à destination incertaine, avant un rendez-vous calé trois mois à l'avance dans l'agenda de ton iPad qui a comme fond d'écran une famille heureuse en bord de mer. Tu ne sais même plus quel bord de mer. La mer elle est la même partout.*[2] Badea does not question time and how it functions, but points to a character who is in an emotional and/ or cognitive aphasia. While our perception of time seems to be the same everywhere (i.e., 24 hours in a day regardless of where we

happen to be geographically), humans should remove themselves from what I call serialized sameness, which, ironically, was created to stimulate and increase productivity.

From Lyon, we move to Dakar, where it seems that we meet a disturbing replica of the previous character, because this too exhibits signs of excessive tiredness. As he admits: *Tu enjambes le corps endormi sur la partie opposée de ton lit/Tu traverses la chambre voisine/ D'autres corps dorment/Tu sors dans la cour/Tu ouvres le robinet et tu plonges ta tête sous l'eau/Une minute tu restes comme ça/Tête sous l'eau/Ton cerveau respire enfin après une nuit peuplée de cauchemars à base de sonneries de téléphone et d'écrans clignotants/ Tu restes sous l'eau et tu resterais encore des heures /Mais le temps file et tu es obligé de le rattraper/Tu mets un short et un T-shirt /Tu bouffes le riz cramé du soir.*[3] Furthermore, the days seem to go on repeat and there is a sickening attraction to this lifestyle. Or maybe no one can do anything to change the sameness of the days ahead. During the third scene we meet just another example of this almost cloned-like character/human. Their identical presence is terrifying because it makes readers ask if these are indeed one and the same character. During the third scene we are in Shanghai, but except for being told so, we could just as easily be either in Lyon, Dakar, or someplace else. The character in this scene gets ready to go to work: *Tu plonges ta tête dans un sceau d'eau/Trois mouvements de brosse à dents/Tu enfiles ton uniforme jaune fluo Made in China et tu sors du dortoir/Pas le temps de regarder ton visage abimé par une eczéma qui passe pas/Tu t'inscris dans la marche commune/Tu coupes l'espace avec tes bras ballants et tu respires/Vous longez les 300 mètres des 17 kilomètres de tapis roulants/les grilles gardées 24 heures sur 24 par des vigiles en militaire.*[4] Without realizing, from Shanghai we go back to Bucharest. It is early in the morning and the female character prepares to go to work while making sure the baby is also fed properly.

Badea lures us in a loop and, once we are there, we cannot escape. When we go back to Lyon, we discover that the character is married, has a child, and also an affair. During his chats with his family, he also engages in flirtatious digital escapades. While he is on the phone with his child, he handles two screens, trying to get the best out of these experiences by maximizing his own *personal* time. Therefore, we could argue that one serious consequence of globalization is to keep people apart, to let a man feel

fatherhood from a distance, to make a child spend a few minutes with his father via a screen, to let a mother return to work even if her body is not fully recovered post pregnancy and birth; in other words, to reduce meaningful inter-actions to something mediated by omnipresent screens. Thus, despite the possibility of being with our dear ones, we realize how they are not physically with us, and their presence is deferred indefinitely.

Therefore, Badea invites us to look around and establish what is real versus what is an illusion. The seventh scene starts with a character who is in Bucharest and wants to get rid of a smell that persists. The new *air*, an illusion in itself, is reachable without any effort by being *pulverized* into an enclosed space. Thus, in making our lives so dependable on schedules and products, how could we stay open for surprise, playfulness, and enjoyment? We expect certain products to have specific results almost like we expect pills to alleviate certain conditions. In another example, a workaholic character uses Mozart's music to relax while he opens many files on a computer compulsively and uncontrollably. Sadly, the office is not the only place that has a robotic atmosphere. Badea shows how the sacred space of one's home is another example for several transactions. In yet another example, while a mother is at work, her child is with a nanny; the mother monitors the infant by asking the latter a series of questions: *Alors tu dis à voix haute maison et ça sonne: Elle a mangé?/Oui/Quoi?/Purée de courgettes/ Bio les courgettes?/Oui/A la vapeur?/Oui/Et là?/Là elle joue./Tu la laisses pas traîner par terre./ Non/Passe aussi l'aspirateur/Oui/Il y a du Biobactinel sous l'évier. /Oui/Tu te laves bien les mains après. Et aujourd'hui pas de parc. Le taux de pollution a explosé. /Oui/ Désinfecte aussi ses peluches/Oui/La température de sa chambre/22/ 19. Tu me la descends à 19. Vas-y bouge/Je bouge.*[5] The examples could also go on and on and on. There is not one single moment of respiro/respite in this very suffocating play that feels more like logs into a diary from hell where people have lost their individuality. Badea does not want us to think there is a quick solution to what these characters experience. The play is extremely dark and it seems to lack the traditional arc. We witness characters' depleting realities while we constantly think of our own.

In the eighth scene, we return to Dakar. The main character wears a fake Versace to impress because he must look like he has his life *together*. The scene is relevant because it brings into

view how workers are poorly treated in factories, as well as the extent of post-colonialism and globalization. For example: *Tu changes de vêtements/Tu mets un costard faux Versace/Tu entres sur la plateforme et tu dis/Appliquez le free sitting/Tu ne parles pas anglais/Tu ne sais pas ce que ça veut dire free/Tu ne sais pas ce que ça veut dire sitting/Mais tu sais ce que ça veut dire free sitting/Et tu sais que c'est un concept moderne de ressources humaines qui consiste à asseoir les employés chaque jour à une place différente pour ne pas lier amitié avec leur voisin/L'amitié au boulot coûte à l'entreprise et on doit diminuer les fuites d'argent. Aujourd'hui je ne veux pas de temps de communication supérieurs à une minute. Et pas de pauses prolongées. Cinq minutes par heure.*[6]

The abuse is in plain sight, so, should we infer that these intersectional aspects have been normalized, or should we realize that certain concepts resist globalization, that is, are not known everywhere? Even if they are introduced, they are not heavily promoted. Needless to say, the characters Badea creates are not free if they cannot act as they please. It's not a question of work ethics; instead, it's a question related to how workers are treated and how those who cannot work somewhere else depend on obscure jobs to keep themselves alive. Moreover, the character in this scene is the one who makes his voice heard by yelling and belittling others.

The next scene is extremely relevant: *J'ai dit Bœuf Bourguignon. Deux fois par semaine on mange français. /J'ai pas trouvé du bœuf/ Alors fait du coq au vin, du gratin dauphinois, de la daube provençale, du confit de canard, du hachis parmentier, du poulet basquaise…/Et tu te mets à réciter toute la liste des plats traditionnels français car tu n'as pas appris par cœur Petit miroir de la civilisation française pour rien/Je ne sais pas comment les faire ces plats/Je m'en fous. Cherche. On ne mange plus sénégalais. On pense français on mange français. Comment travailler pour les Français si on ne mange pas leur bouffe? Nos corps vivent à Dakar mais nos voix travaillent en France. Alors dans les heures du bureau on mange en décalage horaire ce que nos clients mangent chez eux. C'est une technique de marketing tu comprends?*[7]

Senegal was a French colony until its independence in 1960. The main character wants these workers to feel, speak, eat, and act French, when they are not. Badea is not a pioneer exposing these harsh realities, yet she creates an interesting parallel between

post-colonialism and globalization. Should these oppressive moments even be compared? That is, is the former truly over? Is the latter a mutated version of the former? The oppressors might have changed the name, but the tactics have stayed the same: intimidate and/or coerce the "weaker," make them feel like they do not matter, etc.

When we reach the end of the play, we are quite thrilled to have made it because the plot is tough to *digest*. There are almost no stops in between these agonizing scenes. Imagine someone who travels by plane, looks at the world from afar, admits to its beauty, but, sadly, does not have the luxury of time to stop and actually experience their own life. If anything, one is pushed more and more into this unstoppable, widening abyss.[8] The last scene of the play situates us in Shanghai: *Tu t'assois /Tu allumes une lampe de poche et tu commences à calligraphier/Dans le bruit des duchesses victoriennes, des geishas, des vampires, des mandarins, des pirates, des sorcières, des guerrières, des cow-boys, des pharaons, des dragons qui dansent dans le carnaval organisé par le département ressources humaines pour atténuer les effets de la dernière vague de suicides dans l'entreprise/Tu as oublié Chan/Tu as oublié sa respiration sur ton cou/Tu as oublié son corps aspiré par la terre/Tu as oublié l'usage de mots/Tu as oublié de compter jusqu'à 16/Tu as oublié qu'il ne faut pas rompre la chaîne/Tu as oublié qu'on allait tous disparaitre en particules /Car il s'agit de ça: apprendre l'oubli.*[9] We realize that the "cure" for living under these conditions is to forget everything, akin to a debilitating neurological condition of severe memory loss. This is an undeniable tragedy and one of the prices we pay for globalization.

Interestingly, the play does not have any stage directions, no named characters, and we are moved chaotically from one scene/place to another. Badea does not suggest any solution to this mess, so it is up to us to do the rest, thus becoming involved in theater and society. Throughout her play, this line is repeated at key moments: "aiming for excellence." The quest for excellence is not bad inherently; however, to aim only for that, forgetting about the joy of being simultaneously alive and imperfect, that "incarcerates"/incapacitates existence. Here, *excellence* becomes a pale version of the fata morgana motif, especially when we read these lines: "The research department's motto goes round and

round in your head/Aim for excellence/You apply three layers of foundation focusing on your dark circles/And you repeat to yourself quietly/Aim for excellence/I aim for excellence/I will aim for excellence/The smell of burning oil drags you back into the present/3 gulps of coffee a kiss on the little one's forehead/And you grab the bigger one by his arms, dragging him to the car. You tune into Radio France International and repeat every single sentence the journalist says to improve *ton accent français*."

Therefore, the noun excellence is another façade one is asked to wear in order to survive; yet the cost, as we have seen in this play, is to feel torn apart into many pieces by being pulled by simultaneous forces at once, and ultimately being carelessly pulverized – and that is definitely anything but an example of excellence.

In Their Own Words

I was in an artistic residency in France and its main characteristics were to become accustomed to what sociologists call *ville dortoir*, that is, those towns erected and designed during the fifties/sixties in order to house workers from various plants. I started with something from the past only to realize its current manifestations of a global impact. Moreover, I was interested in how much the work conditions were transferring into the intimate aspects of living.

The end.

I'd like them to question everything when it comes to professions and working conditions. I'd also want them to choose carefully as changing professions and/or jobs could have drastic repercussions. We all go through existential crises, but to which extent do they represent our own personal worries, and to which extent are we one of the many, thus losing our individuality?

I am interested to see if female characters can switch tasks and responsibilities, and how quickly they switch roles from subordinate to boss. Also, whenever violence is a part of characters' experiences, we must include that in our plays, so that spectators and readers are reminded of realities that must be corrected.

In order for that to happen, we must create new plays where some characters resist/refuse change, while others fight against it, and, through this duality, to educate the public and let them come to their own conclusions.

I write in a language with a strong colonialist history, so I am very aware of that from the start. This is why, when I write, I do not only focus on the development of characters, but also on how the language itself has a political, social, and intimate impact. I am interested in observing how the usage of the French language in the past still presents signs of aggression and what we can do to ensure that the oppressed, targeted groups are removed from this type of abuse.

Activities

1. Find an example from your behavioral pattern that you know harms you (and others) and try to understand the *mechanism* behind it. No matter how much we educate and improve ourselves, some habits are hard to break. Afterwards, in a circle, each volunteer talks about their annoying, damaging habit. As Badea suggested, there are no direct solutions, except for our willingness to make the first step and to admit publicly a problem. The reason behind this exercise is to detect and acknowledge a harmful behavioral trait, and to notice, as we share it with others, if we could consciously make changes.
2. Tourism could be an exceptional revenue source for a country. However, how are female, *indigenous* owned businesses represented regionally/globally? Find credible sources and create a compare vs. contrast type of expository writing in which you should also touch upon climate crisis and indigenous solutions.

Notes

1 You open your eyes/Your eyelids feel heavy/Your body slides over the bed sheets/Your thigh cramps/Your triceps twitch/Your mouth is parched//You open your eyes and close them again/ Sensory overload/ This doesn't smell like your bed/ Nothing here is yours/ Not the matches, not the plastic bottles of whiskey, /Not the cotton buds/ Not the disposable slippers, the shoe polish/ You've been pulverized and scattered around the space/Time has forgotten you, a lost soul/ suspended between the jumble of latitudes and longitudes/ That crisscross in your brain/Delhi, Tokyo, Dakar, São Paulo, Kiev, Hong Kong, Santiago/ You open your eyes/You cling to your pillow and you try to

remember/For a few seconds you can't pin down where in the world you are/You close your eyes.

2 It's 2.37, here where you are at this exact moment in your life, between planes en route to you can't even remember where, heading to a meeting booked three months in advance in the calendar on your iPad, with a picture of a smiling family on the beach in the background. You're not even sure which beach that was anymore. The sea looks the same everywhere.

3 You step across the sleeping body on the other side of your bed/You slip through the room next door/More sleeping bodies/You head out into the courtyard/You turn on the tap and plunge your head under the water /You stay like that for a whole minute/Head under the water/ Your brain cools at last after a sleep filled with nightmares of screaming telephones and flickering computer screens. You stay under the water, and you'd stay there for hours if you could/But you're against the clock and falling behind/You shove on some shorts and a t-shirt/You wolf down the burnt rice from last night.

4 You plunge your head into a bucket of water/3 quick brushes of your teeth/You slip on your fluorescent yellow uniform *Made in China* and you head out of the dormitory/No time to look at your face, still covered in an eczema you can't seem to shift/You join the morning march/Your arms swing, slicing the air and you breathe / You walk along 300 meters of the 17 kilometers of conveyor belts/The gates are guarded 24/7 by soldiers, …

5 Has she eaten? /– Yep/– What?– Courgette puree/– Were they organic courgettes? /– Yep /– Were they steamed? /– Yep/– And what is she doing now? – Right now she's playing/– You're letting her crawl around on the floor /– No, I'm not/– You still need to vacuum/– Yep/– There's some carpet cleaner under the sink/– Yep/– Wash your hands well afterwards. And no park today. The pollution rate is off the charts. /– Yep/– Disinfect the toys as well/– Yep/– What's the temperature in the bedroom? /– 22/– 19. Lower it to 19 for me. Hurry up, get a move on/ – I'm moving.

6 You change your clothes/You put on your fake Versace suit/You head onto the podium and announce/ "Hot desking only"/You don't speak English/You don't know what *hot* means/You don't know what *desking* means/But you know what *hot desking* means. You know it's a modern human resources concept where employees sit in different seats every day, so they don't get too friendly with their neighbors. /– Friendships in the workplace are a drain on the company and we have to minimize any unnecessary costs. Today I don't want any communication between colleagues to exceed a minute. And no extended breaks. 5 minutes per hour.

Pulvérisés 59

7 I said beef Bourguignon. Twice a week we eat like the French. /– I couldn't find any beef. /– So make coq au vin, dauphinoise potatoes, Provençale stew, duck confit, hachis parmentier, chicken basquaise… /And you start reciting the entire list of traditional French dishes, because you didn't learn the *Reflections on French Society* by heart for nothing. /– I don't know how to make those dishes/– I don't give a shit. Look them up. We don't eat Senegalese dishes anymore. We think like the French, we eat like the French. How can we work for the French if we don't eat their food? Our bodies live in Dakar, but our voices work in France. So, during office hours we eat at the exact same time what our clients are eating for their dinner at home. It's a marketing technique, do you get it?

8 Positive & Negative Consequences of Globalization: www.bbc.co.uk/bitesize/guides/z8436fr/revision/5

9 You sit down/You turn on your torch and begin to draw/Amid the noise of Victorian women, geishas, vampires, mandarins, pirates, witches, warriors, cowboys, pharaohs, and dragons that dance in the fancy dress party below organized by the human resources department to ease the effects of the last batch of suicides /You've forgotten Chen/You've forgotten his breath on your neck/You've forgotten his body sucked into the ground You've forgotten how to use words/You've forgotten to count to 16/You've forgotten that you mustn't break the chain/You've forgotten that we all turn into dust/Because that's what life's all about: learning how to forget.

6 Moss (*Verde Crud*)

Cătălina Florina Florescu

About the Play

For months, I had this one-liner stuck in my head not knowing what to do with it, or if I would even use it. Eventually, it became the first line of *Moss*: "I could have been a great lesbian." I cannot say why this came to me, but it made me smile. I knew that, if I were to develop this further, I'd need an old character to utter these words. However, more months passed, and then, one day, I sat in front of my laptop with more and more lines coming out of me. By now, several ideas had formed in my head. Developed originally as a short story, it had a motto taken from the first female playwright of the world, Hrotsvitha von Gandersheim (935–1001)[1]: "To a brothel you will be consigned, /where your body will be shamefully defiled." This appeared in her piece, *Dulcitius*.[2] While I will not comment on the line in her work here, I would like to talk a little bit about why the word "brothel" hit me hard.

I knew that the piece that I would write had a woman who was full of regrets, who knew that her life was sacrificed, who did not feel love except for a few moments in her past. Even though von Gandersheim lived a very long time ago, this line still gives me shivers because of how the female body remains controlled to this day. Worse, how in 2023 we have not stopped all the crimes perpetuated on female bodies. As I reread this line, I imagine this promiscuous brothel, location irrelevant, and I close my eyes and see women who offer their bodies, women who are coerced into doing exploitative actions, women who do not get to be satisfied having intercourse, but rather having their bodies/minds used as a source for men's pleasure. While I believe that sex work is a legitimate

Figure 6.1 Image from performance. Directors: Florescu, Larsen, & Lozonschi. The Players Theatre, Manhattan, U.S.A., 2020.

Reproduced with permission from the playwright.

job, which should be treated accordingly, and while I write about brothels *en passant*, my perspective focuses on same-sex love when that is denied and its traumatic consequences. Furthermore, I knew that the entire dialogue would be between a grandmother and her granddaughter. My one-act play addresses intersectionality by proposing discussions on ageism and the LGBTQ rights in a patriarchal country like Romania where marriages are heavily restricted and where old people are marginalized.

Back in 2018, I was invited to present at New York University; my talk was entitled "Back to Shame, A Talk about Reproduction,

Violated Rights, and the Traditional Family." This was part of the series on Gender and Transformation in Europe at the Center for European and Mediterranean Studies. Around that time, I was deeply concerned with an abuse about to be committed in Romania and I used my *educated* resources to make sure it did not happen. Back then, the authorities were trying to modify the Constitution by recognizing marriages only between *un bărbat* (i.e., man) and *o femeie* (i.e., woman); to do that, they wanted to ensure that these explicit nouns were in the Constitution, thus replacing the pretty generous, original one, *soți* (i.e., spouses). In Romanian, however, *soți* could also be the plural form for *male spouses*, an ironic Freudian slip, or a vestige for using certain nouns in their masculine version. In a country with serious issues, such as teen pregnancies, accelerated exodus, insufficient medical supplies, etc., this referendum implied financial costs and an abusive attempt to control the population. After my invited presentation, I was even more determined to use my role as an educator in continuing to speak up against the danger of denying Romanian citizens the liberty to speak freely about their lifestyles. For the first 14 years of my life, I lived under communism where our liberties were non-existent, and our lives were vastly manipulated by the Party's brain-washing tactics.

The setting of *Moss* happens in a senior housing complex for people with dementia. Still, we *must* feel the beautiful, however short-lived, past moment experienced in the Băneasa forest, located outside of Bucharest. The fact that the senior lady is afflicted by a progressive degenerative illness should add to the depths of her character. The title of the play is inspired by a moment of passion between two women, as well as by a poem written by Romanian poet George Bacovia (1881–1957), *"Note de primăvară"* (i.e., Spring Arrival). *Moss*, adapted into Romanian as *Verde crud*, references the first buds that signal the arrival of a new spring and its legendary renewal. However, *crud* (i.e., unripe) does have another connotation. When it is used as an adjective that modifies the noun human, the word in Romanian suggests that that person is cruel. Understood that way, the word reflects back to those moments when the senior character was coerced into doing things against her sexual choice. In addition, 60 years separates the grandma from her granddaughter. Neither has a name because I wanted these two women to be mirrors of some sort, as well as a bridge between generations.

Before I delve into sampling from my own play, I need to offer a disclaimer. I am a cis woman. However, there are two major causes that represent the core of my decades-long activism: immigration and sexuality. The former because all people should be regarded as citizens of the world; the latter because what happens in intimacy is nobody's business. When the old woman says: "I could have been a great lesbian,"[3] knowing her mental condition, the young woman assumes her grandmother has an "episode." From the start, the grandma craves to make an important confession. She feels the need to *slowly* traverse her own past, and we need to offer her ample time, so this woman frees herself from this burden. OLD WOMAN: It's dark in my past. It's almost always night there, no day to bother me with the light. YOUNG WOMAN: What's wrong with the light, grandma? OLD WOMAN: Light savages us. I prefer the night, the touch, the kiss. I prefer to imagine how things may flow through me.[4] She does not necessarily hate the night; however, she wants to make sure that her granddaughter does not repeat the same mistake.

After this moment, the granddaughter seems to engage in a routine they both enjoy. This time around, though, the habitual act of combing grandma's hair will reveal hidden paths. The relationship between a woman's hair and her sexuality is still of utmost relevance. In Romanian, we use this expression, *podoaba capilară* (i.e., literally, hair wealth) and we typically consider the hair to be a key seductive element. For *Moss*, the combing of the hair suggests an opening into the forest's clearing since that's where the moment of passion took place. The softness of the hair is an allusion to the velvety description of moss and of what was happening between the two women. OLD WOMAN: We were deep into the woods. She said, "Let me comb your hair." She did not have a hairbrush, though. She snapped her fingers, spread them wide, and... (*Does not say another word but seems to be genuinely happy*) YOUNG WOMAN: Huh?! *Who* combed your hair? OLD WOMAN: Ilinca travelled her fingers all over my hair and then she placed my body gently against a tree and, with the same fingers touching mine, she invited me to touch the moss. That afternoon the moss was wet. We kissed. We made love. (*Turns her head to face the granddaughter*) There were stars shining. *Stars*, my dear, *visible* stars in daylight![5] This beautiful episode is contrasted by what was already decided in her absence. When

she returns home, she discovers that her parents sold her into marriage to a guy whom she met once. The first betrayal happens inside her family. To make things worse, it is the mother who has an oblivious, yet imposing reaction of denying her own daughter the life she was born to live. After a moment of pleasure, there will be a devastation hard to ignore. Moreover, this betrayal is probably more relevant as it happens within what should have been a safe space of one's family. One more time, the heavily marketed as indisputably virtuous traditional family values speak here otherwise. This devastating moment of the first betrayal had to happen in the family to point out that when we rely on outdated images and concepts, we may keep ourselves in the dark. One of my goals in writing this play was to educate about the dangers of perpetuating lies according to which heterosexuality is always fine, normal, and without domestic abuse, and that homosexuality is deviant, sinful, and it should be "fixed."

The stage directions allow for a sound cue that is going to make the old woman relieve more fully her recollection. We listen to bits from Yves Montand's (1921–1991) *La chansonette*, which still makes the young woman think that the only reason why her grandma narrates this story is because it is Friday. On this day, at that facility, they always have French food, movies, and music. When grandma insists with her memory, the following exchange ensues: OLD WOMAN (*Rather annoyed*): Excuse me, are you looking for something? YOUNG WOMAN: *Did* you take your pills today? OLD WOMAN (*Mockingly*): I had my champagne, my pâté, and ... those American, pumpkin flavored mood enhancing pills. Not a great order for my palate. And now I wait for my Coco Channel deux-pièce back from the cleaners. I was a slob last week during our monthly ballroom dance. (*Points, ironically, to her reality*)[6] The old woman's funny side is revealed, which might have helped her deal with the ordeal.

Her lover, on the other hand, realizes that this environment is not where she could live freely. She takes advantage of a scholarship to study visual arts in Paris. This is the moment when OLD WOMAN could have changed the course of her life, if she only had the courage and support from her *traditional* family. OLD WOMAN: When I told Ilinca I would get married soon, she said, "Let's elope." I said no without words, shaking my head.

She was upset: "What do *you* think *you* are doing? This, and she was pointing to the two of us, may go away, but your pleasures should not be denied. *Especially* by you." I kept my head to the ground. Ilinca said: "You know, when my *mother* found out, she took me forcibly to church for conversion[7]." (*Stops. Looks into her granddaughter's eyes, or at the audience*) Those days, they did not call it "conversion." Like it needed a name! It was abusive. Degrading. Shaming. (*Makes a painful sound*) The priest told Ilinca terrible stories from *The Bible,* and she said, "What's that got to do with *me*? What's that got to do with me, huh? What's that got to me, tell me, *tell me*?" She snatched his book of lies out of his clenched hands, dropped it on the floor, stomped on it, and ran away. She heard him saying, "Go to hell, you bitch!" (*Again, to her granddaughter, making sure she understands the severity of the situation*) God's "messenger," so poisoned by hatred trying to poison others! (*A moment*) Ilinca touched my face, kissed me, and repeated, "Let's elope." I whispered, "I am afraid." "Afraid of what?" I had a lump in my throat; I could not speak. Ilinca lifted her blouse and showed me a scar. "Do you see this? That's where *my* mother burned me with the hot iron before I managed to escape. My own mother said *I* was possessed and *I* would burn in hell.[8] This is a crucial moment in the play because the information that grandma gives is too much, and it is thus difficult to process. This is also the moment when the young woman feels there is more to it, that the grandma does not have an "episode," and that she does not know how to make her stop because she has never seen her like this.

Simultaneously, the young woman feels vulnerable and exposed. Briefly, the two women are seen as one, like in a reflection of some sorts. The grandma will give the context when this happened. It was during a time when Romania exorcised those who were embracing their homosexuality. OLD WOMAN: *I* betrayed Ilinca and *myself* that day. *I* chose to have a traditional family. *I* was the good, obedient, heterosexual daughter my parents wanted me to be. It was in the early years after World War II and homosexuals were exorcised in Romania. The last thing Ilinca said to me was: "You fool! *You* have just murdered yourself." After high school she got a scholarship to study art in Paris and never came back. (*Beat*) That day in the woods became intangible, not even mine anymore.

I saw my voluptuous skin abandoning me. I was sick for days. My mother said those were "wedding jitters, stop acting like a child!" She was so ignorant. But I was worse: *I* knew.[9]

While my character is fictitious, it helps to note that during the communist regime in Romania, more exactly starting with 1968, it became unlawful to have same-sex relationships. Article 200[10] was abusive and, if caught or coerced to declare being involved in such sexual relationships, someone could be imprisoned from 1 to 5 years, and sometimes be kept in jail for 15 years. In 2001, Romania finally declared this article unlawful, but there is a shameful reason why that happened. Back then, Romania was in the process of being accepted in the European Union. This organization was heavily demanding our country to align with the union's moral values. It is relevant to write this, however painful, because the change was not done out of respect for the LGBTQ community, but just because the Romanian authorities were pressured to be and act like (Western) Europeans. To commit to make a change pro-forma is extremely dangerous because Romania has remained vastly homophobic.

Back to my play, there is one last big secret from the grandma's past, which aligns perfectly with the motto of my script, as well as with a painting completed by Jean-Léon Gérôme (1825–1904), *The Slave Market*. Before purchasing a female slave, a male buyer assesses publicly her naked body. The painting has a blatant impact to me to this day since we have started to unmask degrading and dangerous male patterns through movements such as #metoo or #TheTimeIsUp. In my play, we discover this disturbing truth: OLD WOMAN: One night, I was thirsty, but for a strong drink. He wasn't home. I opened his liquor cabinet and poured myself a glass of scotch, but what I found was a box full of photos... My husband's grandfather posing next to many women completely naked, satisfying his sexual pleasures... I threw up. When he came back home, I confronted him: "Honey, did you have a good fuck this evening and, by the way, was your grandfather a serial cheater?" I pointed to the box. He laughed in my face: "Man, you are stupid! That was his *business*. He had brothels[11] scattered all over Romania. (*Quite proud*) The *stories* one hears in such places..." His face was distorted. I was beside myself. "Do you mean that you are the heir of a brothel chain?" "Wake up, sweetheart, and *smell* the business. I did pretty good.

You shouldn't complain." I pulled my husband and yelled: Oh, my god, *my* parents knew! *You* knew. *My* parents were my pimps selling me off to you." He looked at me and said, "No, *pussycat*, your father was a terrific businessman, but he lost his fortune gambling and you, ... oh, well, you happened to be the *ransom*." I punched him hard, threw the box in my own vomit, and left. It was raining but I was drenched in my tears. I checked into a hotel and slept for days.[12] After this moment, the two have a heated argument because what the old woman just confessed was detrimental to the overrated ideals of traditional families, to how women are viewed, etc. In choosing to confess, she knows that times have changed, that a woman can stand up and fight for her rights, and, most importantly, that her granddaughter should never have to live without her own access to love freely. We discover that the granddaughter is about to enter a heterosexual marriage, and this is grandma's final attempt to make sure this huge mistake is not repeated. Put on the spot indirectly, the granddaughter finally has her realization: YOUNG WOMAN: My first time with Ramona happened on a cold December day. We were in a sauna. (*Reconnecting with her memory, she is finally ready to tell her truth*) Her towel dropped. I picked it up. I saw all the moles on her back. (*Takes her time*) I touched them. One by one. (*Takes even more time. Let the actress feel the words*) I kissed them one by one. *All the windows open. We are flooded by natural light.* YOUNG WOMAN (*Excitedly*): Grandma, are you here? (*She positions her body to look at her as an adult looks into the eyes of a toddler.* OLD WOMAN *does not respond*) Come back... for a sec... I have something to tell you. (*She waits for a few more seconds*) You can't? Not today? Maybe tomorrow? (*Beat*) Grandma... *Ioana Radu's song is heard.*[13] The play ends with a *romanță*, an old song about love sang by Ioana Radu (1917–1990). *Moss* does not end either sadly or victoriously; still, we know that grandma saves her granddaughter's life, and this is a huge step toward LGBTQ's visibility and their members' much needed given respect. In doing so, she did not lecture anyone, but instead used her traumatic past as a clear illustration of her invaded and invalidated privacy. Consequently, same-sex relationships must be viewed with dignity, as they happen naturally, and trace back to a long, however, closeted history. In talking about intersectionality, discrimination based on sexual preference represents a fundamental, non-negotiable right.

In Their Own Words

As a cis-gender woman, the issues related to intimacy are highly relevant, and I expect everybody to learn to respect people's sexuality. I am glad the referendum that I was talking about before did not pass; however, homo-/bi-/transphobia are shameful realities in Romania. So, I wanted to write a play where a woman retells her past so that her granddaughter chooses following her own desire and not anyone else's. I wanted to make room for a healthy change in attitudes, since there is no scientific proof that queer sex is deviant at all. Being an ally is one thing, backing this up with science and expressing it via a short play are useful tools to express my unconditional support.

An important part is when the old woman talks about her sexual discovery in the woods and how her lover invited her to live together. The action takes place during a time when women could have arranged marriages and the heroine in the play is too afraid to choose on her own. It is also a time when conversion therapy sessions happened, and those were cruel acts depriving people of their sexual freedom and worse, making them feel guilty, making them believe that they were sick and needed help. I would not call it my "favorite" part, but one that is meant to stir something in the readers' naturally born instincts to be empathic.

I want them to realize that attraction is a healthy reaction, that sexual relationships should be consensual, that we do *not* live in a hetero world, and that there are many things to discover when we have an open mind. Moreover, since this play brings into discussion a grandmother and her granddaughter, it is important to see the extent of the betrayal. The old woman betrays herself when she chooses not to run away with her lover. She is betrayed by her parents who already arranged a marriage with a promiscuous man just to take care of their own financial problems. She is betrayed by a set of misleading beliefs that keep reminding her that she is "sick" and needs to be "rescued."

I am not a feminist; if anything, I am a womanist, but even this label cramps my style. I am a human being who writes on themes that, like our bodies/minds, are still broken and need to be remedied with educated love and maturity. My background in Medical Humanities allows me to construct my pieces from an observer's impartial points of view, someone who listens to other people's

stories, take notes, and then turns them into a play. I strongly believe there should be sex education courses in middle school, high school, and beyond. We should familiarize ourselves with our physical and emotional needs and stop being ashamed to ask for mental support and/or any other type of assistance in matters related to sex. First, it gives the possibility for two women to be the performers. Second, a female director and a creative team could make the piece an irrefutably *feminine* statement.

I came to the States at 23. After I finished my Ph.D., with a toddler in one hand and a diploma in another, I started my career as an educator. The Romanian and American governments have an agreement that allows graduate students to work from one to three years on a specially granted working visa. Once mine expired, and since, at the time, I did not have a legal alien card, I could not work for two hellish years. My skin is white, yet, aside from that, as an immigrant woman and a working mother, I encountered discriminations starting with finding a job to raising a child on my own.

Activities

1. Play "Two truths and one lie" and instruct students/participants that one secret or lie refers to something about their bodies. Let them explore whatever may be revealed. Then, allow them time to reflect and develop a devised piece based on what they have just discovered/revealed. Title that collective work however you may see fit.
2. Research artwork produced by LGBTQ artists. Choose one painting/photo/installation and create a dramatic dialogue where FEAR is a gender fluid character in therapy.

Notes

1 About her: www.thoughtco.com/hrotsvitha-von-gandersheim-3529674
2 *Hrotsvit of Gandersheim – A Florilegium of Her Works* ed. by Katerina Wilson.
3 Aş fi putut să fiu o lesbiană pe cinste.
4 FEMEIA BĂTRÂNĂ (*Se uită fix, în gol*): Este atât de întunecat în trecutul meu. E ca şi când e doar o lungă, nesfârşită noapte. (*Alt ton*)

Lumina mă sâcâie. FEMEIA TÂNĂRĂ: Și ce e rău cu lumina, buni? FEMEIA BĂTRÂNĂ (*Dur*): Ce e rău? Hm! Lumina sfâșâie. Noaptea e mai blândă cu noi... un sărut... o atingere... totul e în noi, amplificat. (*Cu subînțeles,*) Noaptea este senzuală.
5 FEMEIA BĂTRÂNĂ: Eram în pădure la Băneasa. Mi-a spus: "Lasă-mă să îți ating părul". Am lăsat-o. Numai că ea nu avea nicio perie. Și-a întins mâinile, și-a deschis degetele și apoi mi-a cuprins tot părul în degetele ei... și... (*Nu mai zice nimic.* Un pic mai multă lumină cât să o zărim pe FEMEIA TÂNĂRĂ) FEMEIA TÂNĂRĂ: Ce tot spui? Cine se juca prin părul tău? FEMEIA BĂTRÂNĂ: Ilinca își plimba degetele prin părul meu, mișcându-le în sus și-n jos, lent, cu tandrețe și apoi, corpurile noastre erau cât p-aci să cadă, ne-am sprijinit de un copac.... era plin de mușchi. Ilinca mi-a luat palma în palma ei și am atins amândouă mușchiul copacului. *Era* umed. Era catifelat. Ne-am sărutat. Am făcut dragoste. (*Visând,*) Stele au apărut pe cer. (*Își întoarce capul către nepoată*) Stele în plină zi, îți dai seama?
6 FEMEIA BĂTRÂNĂ: Pot să te ajut cu ceva? FEMEIA TÂNĂRĂ: Ți-ai luat pastilele azi? FEMEIA BĂTRÂNĂ (*Obraznic/ răutăcios/ironic*): Am început ziua cu șampanie, un pic de pateu de gâscă și apoi am luat și pastilele... dar dacă vrei să știi nu mi-a plăcut combinația. Acum aștept să îmi aducă deux-pièce-ul Channel de la curățătorie. L-am pătat la balul mascat de săptămâna trecută. (*Arată în jur la cât de auster este totul*)
7 "The Lies and Dangers of Efforts to Change Sexual Orientation or Gender Identity": www.hrc.org/resources/the-lies-and-dangers-of-rep arative-therapy
8 FEMEIA BĂTRÂNĂ: Când i-am zis Ilincăi că mă voi mărita, mi-a zis, "Haide să fugim!" "Mi-e frică", i-am zis. "Frică de ce?" Nu am știut ce să îi răspund. Mi-a zis că mama ei a dus-o cu forța la biserică când a aflat. "Cum a aflat?" "Din desene..." "Ah, da... am uitat, tu desenezi frumos. Toată școala știe". A zis că mama a dus-o la popă ca să o lepede de păcat. Nu îi ziceau cum îi spune acum, conversie, reeducare, nu... dar nici nu conta! Era un abuz. Și popa îi tot citea din Biblie și Ilinca îl întreba, "Ce are asta de-a face cu mine? Zi! Zi!" Și pentru că nu îi răspundea, atunci Ilinca, înfuriată, i-a luat Biblia din mână, a dat cu ea de pământ, și a fugit. Și popa urla după ea, "Spurcato. Direct la dracu' de duci!" Un preot plin de ură. (*Un moment*) Ilinca mi-a luat capul în mâinile ei și mi-a șoptit, "Trebuie să fugim. Nu îți fie frică". Nu puteam să zic nimic. Aveam un nod în gât. Tremuram. Ilinca și-a ridicat bluza și am văzut o cicatrice. "Uite, vezi, pune mâna...aici, mama m-a ars cu fierul de călcat. Mi-a zis că sunt posedată și că voi arde în iad.
9 FEMEIA BĂTRÂNĂ: Ascultă atent... în ziua aia am trădat-o și pe Ilinca și pe mine. Am ales să am o familie tradițională. Am ales

să ascult. Să fiu fetița cuminte, heterosexuală pe care și-o doreau ai mei. Era imediat după al Doilea Război Mondial și în România un homesexual era considerat bolnav mintal, un spurcat, unul demonizat căruia trebuia să i se facă exorcism. Ultima chestie pe care mi-a zis-o Ilinca a fost, "Te-ai distrus singură" și apoi a plecat. A terminat liceul, a luat o bursă de studii la Paris și n-am mai văzut-o niciodată. (*Un moment*) Ziua aia din pădurea de la Băneasa a devenit din ce în ce mai încețoșată. Corpul meu voluptos s-a făcut de lemn, de piatră, de metal... și maică-mea vedea că nu sunt bine și îmi zicea, "Lasă, tu, așa e înainte de nuntă. O să treacă". Ce proastă! Numai că eu eram și mai și... eu știam... dar alesesem să nu fac nimic.
10 Article 200 of the Penal Code: www.amnesty.org/en/documents/eur39/003/1994/en/
11 While this book does not delve into emancipated discussions about sex workers worldwide, that topic is indirectly suggested in my play.
12 FEMEIA BĂTRÂNĂ: Într-o seară vroiam să beau ceva... ceva tare, nu orice. El nu era acasă. Am deschis la colecția lui de whisky și am dat peste o cutiuță... mică... cochetă... cu o fundă roșie. Nu o văzusem până atunci. Era plină de poze cu femei dezbrăcate care îi făceau toate plăcerile sexuale bunicului soțului meu. Am început să vomit. L-am așteptat să vină și când a intrat pe ușă i-am zis: "Cum a fost futaiul din seara asta, dragă, și, de curiozitate, tac-tu mare era obsedat sexual?" Arăt către cutiuță. Începe să râdă, să mă ia peste picior: "Dar ești bătută-n cap de-a binelea. Tataie era om de afaceri. Ăsta era business-ul lui. Avea bordeluri. (*Chiar mândru*) Mama mia, ce povești mai auzi din asemenea locuri..." Fața lui nu mai era umană... avea rânjetul ăluia care știe că poate să fută orice oricând, că femeile stau să îl aștepte la ușă dezbrăcate. Nu puteam crede că aud bine. "Stai așa, bunicul tău cu asta se ocupa?" "Dragă, ți-a luat ceva timp să te prinzi... niciodată nu e prea târziu". L-am apucat furios de mânecă și i-am zis: "Tu... Tu ai știut.. Ai mei... oh, ... totul se învârte... ai mei au știut. Părinții mei m-au vândut ție în căsătorie". Cu ochii plini de sex, elecrificați, mi-a zis: "Tac-tu a fost om de afaceri, dar când a pierdut totul la poker tu ai fost răsplata". L-am lovit, am aruncat cutia în vomă, și am fugit unde am văzut cu ochii... Afară ploua, dar eu îmi simțeam doar lacrimile cum se adânceau în piele. M-am dus la un hotel și am dormit zile în șir.
13 FEMEIA TÂNĂRĂ: Prima mea dată cu Ramona a fost într-o zi în decembrie. Era frig afară. M-am dus la saună. Prosopul i-a căzut. M-am aplecat să îl ridic. I-am văzut aluntițele de pe spate. (*Își dă timp să retrăiască momentul*) I le-am atins. Una câte una. I le-am sărutat. Una câte una. Toate ferestrele se deschid brusc. Suntem inundați de lumină. FEMEIA TÂNĂRĂ aleargă către bunică. FEMEIA TÂNĂRĂ: Buni... buni... (*O privește cum ar privi un adult un copil*

mic în ochi, așezându-se la nivelul celui mic. FEMEIA BĂTRÂNĂ se uită în gol) Hai, buni, întoarce-te. Am să îți zic ceva. (*Mai așteaptă un pic*) Nu poți? Nu azi? Poate mâine? Buni... FEMEIA BĂTRÂNĂ *nu îi răspunde.* FEMEIA TÂNĂRĂ *se ridică. O atinge pe păr. Se aude melodia* "Și în chioșc fanfara cânta" *de Ioana Radu, romanțe, Parisul este o amintire; două femei și-au spus secretele.*

7 Hai Să Vorbim Despre Viaţă! (Let's Talk About Life!)

Ana Sorina Corneanu

About the Play

Corneanu is the youngest playwright included in this volume, yet her voice is of a very insightful, mature, and passionate woman. The only character of her play is Greta, someone very close to Corneanu's demographic, i.e., a woman in her late twenties, early thirties, skinny, dark hair, and romantically independent. When we meet the character, she is dressed in an office suit, and we are told that it does not fit her – an intentional double entendre. Technically, the play is a monologue in which the protagonist speaks with her alter ego. Corneanu plays with us by using a simple technique of asking questions. In her succinct play, there are 69 questions! Only towards the end, Greta stops asking questions, maybe in part because she has clarified her own points of view, maybe because she knows that no one can answer all her questions, or maybe Greta simply does not care what others think about her choices anymore.

What exactly is going on with this young woman? The simple answer is that she has a dream that seems to be deferred, or almost impossible to achieve. She hopes that the phone would ring, and she would be called directly from the famous *Большой театр* (Russian for Bolshoi Theater), where she would be asked to perform the dance of her lifetime. But the phone refuses to ring and Greta transfers the function of a ringtone into a series of questions that become overwhelming. We are face to face with her open psyche and it's unbearable, however ruthlessly honest that attempt may be. She is dressed in what clearly makes her feel awful about herself because the clothes were chosen to fit

DOI: 10.4324/9781003047711-7

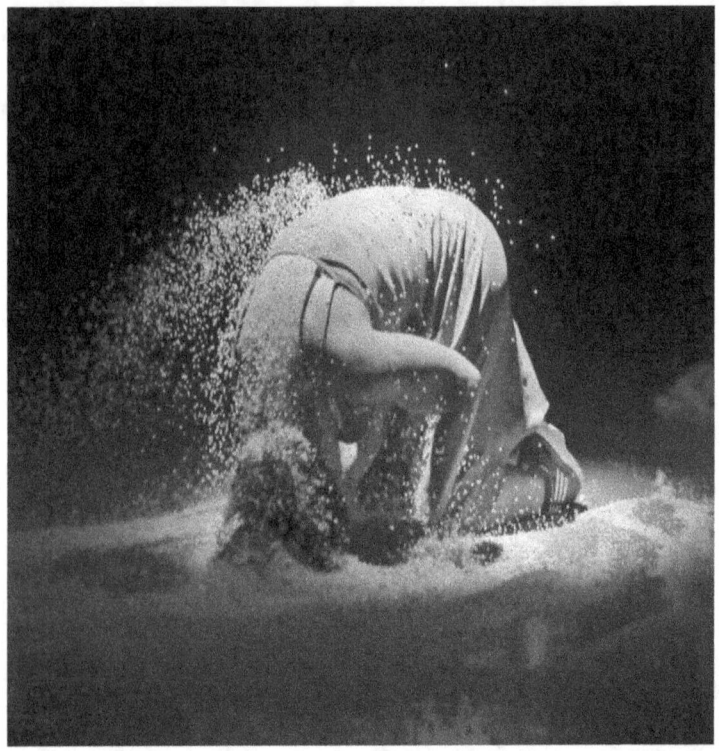

Figure 7.1 Image from performance. Director: Zsuzsánna Kovács. National Theater in Bucharest, Romania, 2021.

Reproduced with permission from the playwright.

a person ready for an interview, to secure a job that she does not want, and to project to other people an image they want to see. Like I said before, GRETA is not here to lament about her predestined condition "as a woman," but instead to make us feel and inhabit that burden; she does that via the Socratic method of raising questions. This technique implies a dialogue, which here is done via an alter ego that suddenly disappears mid-part of the play. The first line of the play is a question: *Avem un minim control asupra vieții… sau totul stă scris?*[1] How many times have we heard this dilemma? Are we in total control of our lives, or do we

believe that our destinies have been decided by unseen forces? Do we have free will? During the first part of the play, GRETA talks to her alter ego, which warns her to avoid entering her own mind. This does not sound right. However, imagine a parent, guardian, or teacher who thinks they know more because of age and experience, and they warn their kid/student to avoid making irresponsible decisions with potentially severe consequences. The first question that GRETA asks herself (and us) is neither new, nor existentially loaded. On the contrary, it seems like a safe one precisely because it has been said too many times before by too many people. But the alter ego senses something different because the second line of the play is: *Nu intra!*[2] In other words, her protective alter ego does not want to see GRETA make a mistake. But what if the alter ego is just as manipulative as all the other exterior forces and entities, what if this alter ego does not want GRETA to evolve? Or is it possible that the alter ego is truly selfless and wants to protect GRETA unconditionally? *ALTER EGO: Știi ce vrei, Greta. Și asta e cel mai important. GRETA: Cum știu?ALTER EGO: Simți! [...] Singurul lucru în neregulă e că ești aici și vrei să intri. Nu ți-e teamă că o să devii una dintre cei mulți? GRETA: Mi-e teamă de cum o să arate viitorul... ALTER EGO: Vrei să faci lucrurile din teamă? Din teamă se nasc mulți copii, se fac multe credite, multe compromisuri – și se minte mult.*[3] It is now more evident that GRETA's alter ego has respectable intentions, and, if we were to follow a good versus evil scenario, then, in this case the woman herself is her own enemy, while her alter ego wants to help. She is already here for a job interview, but until someone comes to acknowledge her presence, she has time to engage in existential escapism. This is where she should not be, that is, this is exactly what her alter ego warned her about. Actions influenced by fear cannot but eventually ruin someone, especially someone like GRETA who struggles to quiet down all the "voices" that keep reminding her of what she should have already achieved in her twenties.

In a subtle move, we see GRETA becoming "disembodied" right in front of our eyes when the alter ego talks about her, trying to make us feel what's inside her body/mind. *GRETA: Dacă muncesc 12 ore pe zi–ca să asigure pâinea copiilor, atunci evident că nu au timp de astfel de gânduri și întrebări. Atât ți-ar trebui, să te apuci să deschizi subiectul, imediat ți-ar răspunde cu ocară–să*

te potolești cu prostiile astea. Au lucruri mai bune la care să se gândească, nu au timp de crize existențiale. Nu-și permit să facă filosofie. Nu mai gândesc cu mintea, ci cu stomacul. Văd lumea în facturi, griji, cifre, nevoi imediate. ALTER EGO: Nu e vocea ei. E a lor. O fac să se simtă vinovată. Se simte vinovată că are timp să se gândească la ciclul existențial. Că nu are trei copii cărora să le asigure pâinea, că are gânduri și întrebări fără legătură cu realitatea imediată.[4] The reason why GRETA has so much time to spare is because she is not *feeling* herself, however eerie that may sound. She did everything that she was told: went to school, graduated, worked hard to achieve her biggest dream, but she is not quite there "yet." Let's pause and revisit how we activate our habitual, possibly unrealistic thoughts that one day things and attitudes will be better, that working diligently will pay off, etc. We keep doing that, projecting ourselves into a future that is not exactly grounded in facts but in dreams. At one moment in our lives, we must have heard something similar to what the female protagonist is told: *GRETA: N-ai terminat facultatea la 21? Ai împlinit 24 în facultate? Studiezi la infinit? Pariaaa! Ai 25, tot singur ești? Trece timpul, dacă nu te-a cerut până acum...sigur nu vrea nimic serios de la tine. Vezi că ...acum sufli-n tortul cu 30 de lumânări, ar trebui să faci asta cu copilul pe picioare. Ai împlinit 30 și n-ai un copil în plan?*[5]

Interestingly, GRETA has her first breakthrough while she analyzes herself and alter ego and does that (partly) through illeism. This is the moment when she decides to speak about who she is from the first and not third person perspective. Unbeknownst to her, she is a great observer and her own diligent therapist. An alter ego could be indeed someone's best friend on whom they may be able to rely during tough moments of life, or the opposite of their personality. Still, the female protagonist feels like she must part ways with her own alter ego; moreover, when she switches the angle and starts talking about herself from the first-person perspective, she may finally *own* her mistakes, destiny, and freedom. *GRETA: Nu știu dacă ați observat, am renunțat să vorbesc despre mine la persoana a treia. Ea face, ea crede, ea știe. Ea sunt eu. Cred că v-ați dat seama...oricum. E un truc, să vorbești despre tine la persoana a treia e ca și cum pasezi altcuiva ce simți tu–și te eliberezi de responsabilitate și asumarea a ceea ce alții e posibil să nu accepte. E un skill social bine pus la punct, foarte utilizat. Exact ca atunci*

când vrei să afli ceva, dar nu vrei să știe ceilalți că întrebi pentru tine, așa că spui Întreb pentru un prieten. Evident că toți știu că e vorba despre tine, dar tu te poți preface că nu știe nimeni. Îți dă curaj. E ca și cum vorbești cu tine. Despre tine. Ai o viziune dublă asupra ta; și obiectivă–și subiectivă. Poți alege când să fii asumat și când să pasezi responsabilitatea.[6] Instinctively, she knows she must assume responsibility, understand the consequences of her choices, and move on. When we meet her, she is at a crossroad and, like Janus, looks backwards and forwards at the same time. Eventually, GRETA leans towards looking only in one direction hoping that that could give her much needed peace of mind.

Her turmoil, borderline self-destructive, could be overwhelming, and her angst is palpable. GRETA is probably one of the most analytical characters I have ever encountered. She does not rush into action but gives herself time to investigate. We reach our late twenties, move into our thirties thinking we know enough. We wake up, engage in our daily routines, and the like. But are we genuinely *happy*? Do we do these activities simply because we do not know any better, or because we are afraid to try new ones? How often do we stop from what we are doing to employ the Socratic method, thus refusing the temptation of reaching *easy* answers? Amidst this avalanche of questions, there is one word that truly made me feel this character. As GRETA says: *Ada, prietena mea vorbea ca o tâmpită, se lăuda cu faptul că s-a măritat și a făcut repede de tot un copil, simte că a realizat ceva în viață. Mi-a zis că s-a așezat la casa ei și nu mai trebuie să facă eforturi: nici profesionale, nici financiare, de niciun fel. Trebuie doar să suporte urletele copilului. S-a desăvârșit. N-aveam cum să mint că-mi doresc același lucru și eu. S-a supărat degeaba când i-am zis că viața nu e doar despre confortul ăsta primitiv.*[7] Namely, "to achieve" is used twice: one time in regard to material and biological aspects of having corpo*reality*; the second time it is used to define and equally end or put in danger a destiny. Admittedly, we need a minimum comfort/reassurance to go on with our lives. The second time, however, the word feels like a death sentence, especially if we look at it through an intersectionality lens. The woman in question sacrifices herself to receive comfort because she truly believes this, or she is *made* to believe that her duty is to become a wife and a mother. This is how she may *achieve* the invisible "badge" of being a good woman. There is no space for self-development. There is

an apartment and a child who cries, and that is not exactly a definition for an achievement, but for a predicament.[8]

I think the woman mentioned above, Ada, does not want to give herself time to grow. She prefers to follow norms. She does not ask questions. Corneanu plays with the noun *gură* (i.e., mouth) in a subtle way. First, there is the nightmare her character experiences. Then, we realize the source of her terrifying thoughts and how she has internalized them. *GRETA: ... gura lumii e cea mai nesătulă. [...] Pentru că muncesc să întreţină gura lumii. De la 9 la 6–şi peste program–muncesc ca să hrănească gura lumii. Doar că ea nu se satură niciodată. [...] Eu vreau să hrănesc gura lumii cu nisipul ăla ud, ăla care-mi curge din gură când mă trezesc în miezul nopţii, ăla pe care îl rănesc cu pumnii. Să fiu prim-balerină la Balshoi şi să nu mă mai intereseze ce urmează... mai mult decât ce e aici şi acum.*[9] In an attempt to free herself of all the pressing dominant forces, GRETA wants us to see how suffocating she feels in that office suit for her job interview: *Mi-e teamă că nu-mi voi găsi locul între pereţii de sticlă, că o să trebuiască să râd la glumele lor proaste, în pauzele de ţigară, ca o să trebuiască să zâmbesc fals în pozele făcute ca să demonstrăm pe social media că suntem o echipă veselă şi sudată.*[10] This is it. This pretend show must end! She cannot take this pressure anymore. It's either to live this nightmare for the rest of her life, or to escape what does not <u>suit</u> her. GRETA leaves the stage, but before she does that, her last spoken words are: *Dansaţi, dansaţi, altfel suntem pierduţi!*[11] I personally took the liberty to translate *pierduţi* in three different ways because it is not only the act of temporarily being lost, as the word may transmit at a first look. It is also being doomed and possibly even "dead" inside. According to stage directions, the play ends like this: *Greta dansează. [...] Greta dezbrăcând haine oficiale [...] un telefon mobil sună.*[12]

Towards the end of the play, we see the protagonist do what she loves the most. It does not really matter if her dream to dance on the stage of the Bolshoi Theater will ever come true, or if she will ever be Odette from the famous *Swan Lake* by Pyotr Tchaikovsky (1840–1893). What matters is what she leaves behind, and especially what she leaves us with. When the lights return on stage, there is a pair of ballet shoes and a phone that starts to ring. Both are for us because the advice to dance so that *we feel alive* comes from one of the most revolutionary dancers of our times, Pina

Bausch (1940–2009). When GRETA *embodies* these words, she channels the beauty and fragility that Bausch always exhibited on stage. We do not have to be professional dancers to give meaning to our bodies. We can stand up, walk, transform those steps into whichever impromptu choreography we may discover. After all, if we can focus on our bodies' needs, hopefully we will be able to follow the advice given in the title of this play: *Let's Talk about Life!*, where "to talk" has a contextual synonym, "to dance." That should be enough, thus placing the emphasis on our bodies, and, in return, quieting our racing minds.

In Their Own Words

I was working part time at a marketing agency, where I was writing screenplays to promote their services. I didn't like the environment at all, and I didn't find myself in what I was doing. Basically, what they said we would be doing during the interview, turned into the opposite of what a creative work should be. Everything during the interview was staged. I felt trapped, day after day, without finding the courage to leave that job. As an independent actress, I needed time to invest in myself. One day, after work, I was lying in bed and blasting "Lakmé, the Flower Duet" by Léo Delibes. I closed my eyes and I saw a ballerina dancing among the cars, somewhere in a busy intersection in Bucharest. From there, everything flowed like magic. I got out of bed and started writing. I resigned. I was somehow grateful that those people *motivated* me to write as I pleased.

I think my favorite part is the short passage that crosses the dream area. I'm fascinated by dreams, and I always try to overanalyze them, up to the last symbol, then use them in what I write. It's a personal tool to deal with some of my fears that I wouldn't otherwise have the strength to talk about, not even in writing. So, any dream allows me to talk about my fears without pronouncing or *revealing* them.

I would like them to sit on the first bench in a nearby park and reflect for a little while. I'd like each reader/spectator to allow themselves the space to absorb what Greta has been sharing with them. Once, I knew a woman who hated her job, wanted to do something else, and was carrying an invisible burden daily, while from the outside she appeared fully functional. One day, she died

because she had a stroke, most likely due to accumulated stress and deferred dreams. My message? Don't take anything for granted. I sincerely hope that this character that I created is not viewed as a neurotic who asks questions, but instead as an oasis of self-worth. I think we need to give women more opportunities to express who they are and what they feel, without considering that there is something wrong simply because they have/aspire to have other dreams. For example, just because someone is a woman of a "certain age" that does not mean that that person has the *duty* to get married and have children. Going back to my play, Greta feels this pressure intensely. In a way, her process of reevaluating herself begins there.

My play wants to tear down everything that is related to male domination and to establish the other's acceptance for who they are, giving them the chance to express themselves as they feel. I really believe that we are who we truly are inside, unrelated to the gender, race, or the most intimate of our choices. The right education is acceptance.

Intersectionality is an opportunity to remind everyone that we are not numbers, colors, patterns, but persons who have stories to live and tell. I'd like to put more emphasis on "who I am," and not on "how I am." A new *normal* must be fair for all.

Activities

1. Inspired by the play's origin, pair up students/volunteers and invite them to exchange one of their favorite songs. While they listen to it repeatedly, instruct them to observe the other's features, reactions, clothes, postures, idiosyncrasies – anything and everything. Then, switch perspective. Introduce the Dalcroze method, its focus on musical expression through movement, and its goal of applying music so that we awaken our senses, especially the kinesthetic one. Finally, ask participants to write a monologue where they pretend to "be" the other-qua-fleeting-moment-in-time. How did the song, their observations, and the Dalcroze method influence/inform the writing?
2. "Dreaming realities" is a project where you interview two women who did pursue their dreams despite societal pressures and hardships. Based on their advice and lessons, create a collective, aspirational, and motivational quilt. Ideally, choose vibrant fabrics, sew life-affirming words, and add any reflective materials/objects.

Notes

1 Do we have a say in our lives, however small, ... or is everything already decided for us?
2 Do not enter!
3 ALTER EGO: You know what you want, Greta. And that's the most important thing. GRETA: How do I know? ALTER EGO: You feel! [...] The only thing that's really a red flag is that you are here right now, and you want to get in. Aren't you concerned that once you do that, you will become one of many? GRETA: I'm mortified of what's going to be in the future. ALTER EGO: So, wait a second... if I hear you right, you want to do things not because you are convinced they work for you, but because so many others are doing them. I see. You are afraid. Let me tell you something: if you choose fear, that's going to haunt you. All actions made in fear have consequences: a baby, a credit loan, compromises – oh, and all these are actually lies because fear guided you to choose, and not your own needs.
4 GRETA: People who work 12 hours a day to put bread on the table for their kids do not have time to ask questions. In fact, if you try to engage them in a conversation, they would be very rude and remind you to stop with these silly ideas. They would remind you they have better things to worry about and all these existential crises are a waste of time. In fact, they do not have time to waste. They think through the needs of their stomach, to satisfy that first, and they do not have time to fool around. The world for them is a sum of their bills, worries, numbers, and immediate needs. ALTER EGO: This is not her voice, but someone else's. These people make Greta feel guilty. She has time to think. They do not. She does not have three kids to worry about constantly. She has too much free time to waste on this philosophical nonsense.
5 You are 21. Why haven't you finished your bachelor's degree? Did you turn 24 *while* still being in school? What the fuck, are you studying *ad infinitum*? Pariah! Are you still single at 25? Time flies, dear, if you have not been proposed into marriage yet, you are just a fling for him. Are you in your thirties and you don't have a baby yet? What, you do not even think about having one?
6 I'm not sure if you have noticed, but I stopped talking about myself in the third person. *She does this, she thinks.* I am myself. I think you have ... noticed. It's a trick, really, to talk about yourself that way because it makes you feel as if you are transferring your own self onto someone else, it's like you free yourself of some responsibilities and whatever other people may disapprove of you and gift them to this illusion of another person. It's a very well-designed social skill and used quite frequently. Like, for example, when you ask a question *for a friend*.

Everybody knows it's really about you, but that gives you courage. It is as if you talk with yourself about yourself. You get a double vision about yourself: an objective and a subjective one. You can choose when to accept responsibility and when to give it to someone else.

7 GRETA: Ada, my friend, was just talking gibberish, I mean, listen, she was saying proudly that she got married, got pregnant, and she feels that she really accomplished something. She said that now she owns an apartment, and she doesn't have to worry about any financial or professional needs. She is worry-free. I mean all she had to do is to tolerate her child's cries. She said she has accomplished herself. Deep down, I think I want the same thing. She got angry when I told her that there must be something more to life than this.

8 "Is Feminism Still a Real Thing in Romania?" by Alexandra Klara. Vide *Appendix*.

9 GRETA: Public opinion is the worst. [...] Some people work only to satisfy these public views. They work from 9 to 6, and sometimes even extra hours, and they overwork to ensure public view is met and satisfied. The problem is that the public opinion is constantly hungry and greedy. [...] I want to invite public opinion to dine with me, only that I would feed it a spoonful of that sand I keep getting in my mouth in my nightmares, all that sand that I keep digging with my bare hands. I want to be the number one dancer at Bolshoi, and I do not care about any future plans... I want that to happen right now. I want to live in the present.

10 GRETA: I am terrified that I will totally lose who I am, confined in a cubicle, that I would have to be polite to force myself to laugh at their jokes while we have a cigarette break, that my smile would be fake and forced, just so we look like we are a perfect team on social media – a great team, just like a family.

11 GRETA: Dance, dance, dance – otherwise we are just lost!

12 GRETA *is dancing.* GRETA *is taking off her suit. A cell phone is heard ringing.*

8 *Familia Offline* (Offline Family)

Mihaela Michailov

About the Play

Dr. Michailov is one of the strongest voices in contemporary Romanian theater, tackling issues related to society's direst problems. She is one of the founders of Replika, an award-winning space where experimental plays are performed, the audience is actively invited to participate, and one feels safe to be vulnerable. In *Familia Offline*, Michailov signals that the so-called solid (reproductive) pillar of our society is literally and bluntly put, off. From the start, the playwright zooms into what "family" could connote intergenerationally. After the fall of communism, when borders opened, Romanians could travel freely everywhere. Due to severe socio-economic and political insecurities, however, Romania suffered one of its most terrible blows related to workforce and, subsequently, a massive migration ensued.[1]

Before I analyze anything, let me state clearly that this a very shocking, upsetting reality. During communism, Romanians could travel to countries that had the same political type of government and doctrines. On extremely rare occasions, we saw, held in our hands, and/or enjoyed products coming from the West. We dreamt about their lifestyles and hoped that one day we would have unlimited access to better options. The reason why many intellectuals and workers left Romania after 1989 varies from issues related to corruption, poorly paid and not reliable jobs, and outdated, harmful mentalities. The tragedy was catastrophic: more people left Romania when the country started to be governed democratically than under the dictator's harsh time, and that says a lot! Therefore, in this play, "offline" also means something related to how family

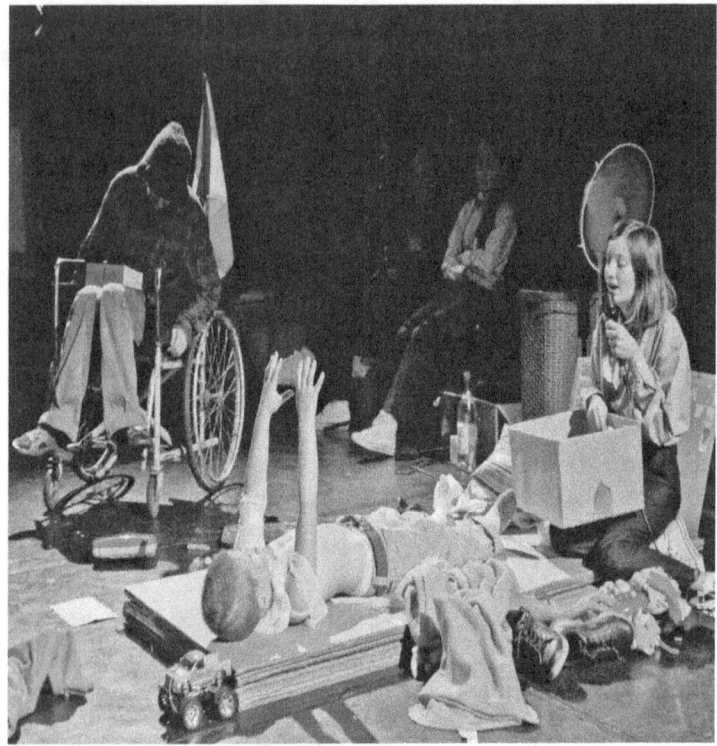

Figure 8.1 Image from performance. Director: Radu Apostol. Centrul Replika, Bucharest, 2007.

Reproduced with permission from the playwright.

relationships do not happen in person but are mediated by technology, which has its own limitations. As we discover, Michailov adds other possible connotations to the word "offline."

During the first scene of the play, *În pericol!*,[2] the playwright does not spare our feelings; instead, we are forced to face the exact reality of this family. Since the grandpa is unfit to raise his grandchildren, they are each other's unqualified guardians. By juxtaposing these two generations and by leaving the parents outside of the script, Michailov creates a scenario where we cannot take our eyes away. The grandpa is also left behind by a system in which the

ageing population is blatantly ignored, their pension is insufficient, and so, senior citizens are left to barely live another day. If these were not enough triggering notes to paint a devastating reality, when parents leave their kids so the former work in Europe, the playwright presents chaotic scenes from a *broken* family with no functional adult on site. Furthermore, sexism plays another huge role because the oldest girl is given the unsolicited role of a surrogate mother. *CRISTA: Nu ştiu cum să mai vorbesc cu copiii ăştia! I-am scăpat din mîini.*[3] *VICE: Fraiero! CRISTA: O să te spun!!! VICE: Cui?! CRISTA: Lu' mama! VICE: Păi nu eşti tu mama?! CRISTA: Lu' mama mama!!! VICE: Mama nu e! ...CRISTA:Da' o să fie!*[4] The first scene of the play signals a level of dysfunctionality that's heartbreaking. Theoretically speaking, these children are not orphans, even if they are abandoned for many months. Kids from such broken environments prefer to stay as a pack, together, rather than become institutionalized.

From the opening scene, we move into the second which is going to reveal more injustices. *Haideţi la şcoală!*[5] is a short-lived welcoming note because we soon realize that with no parent or functional guardian in their lives, the school is not able to handle the children's traumatic situation either; consequently, they cannot motivate themselves to go to school. CRISTA is the "mother" and a tutor at the same time, but she is a child: *CRISTA: Tonto, la română, ţi-ai făcut!? Tonto!? Ce-ai avut de scris? BUNICU (spune foarte repede, toţi îşi pun mâinile la ureche):Mişu are şapte cocoşi. Toma este cu Lică. Ei stau pe o plută. Apa este rece. Lică este pescar. El a prins un crap. Păunul are pene colorate. Piper. Pom. Copil. Penar. Sorina are alune. CRISTA: Nu dumneata, bunicule! Tonto, la română, ţi-ai făcut!? Tonto!? Ce-ai avut de scris?! Tonto nu răspunde. Crista reia întrebarea. Vice îl loveşte iar pe sub masă. Atunci brusc, Tonto se ridică în picioare pe scaun, scoate caietul-manual de limba română şi citeşte apăsat din caietmanual. TONTO (citeşte): "Construiţi câte o frază plecând de la următoarele enunţuri: "Puncte, puncte, puncte "şi mama mă vede." BUNICU: "Puncte, puncte, puncte" ... şi Romică are pere! ... Noi locuim în ţara noastră, România. CRISTA: Nu dumneata! TONTO (citeşte): "Mă râd, mă joc, mă sar, mă vin de la şcoală, mă fac lecţii şi mama mă vede." Puncte, puncte, puncte"noaptea mama mă sărută." (citeşte) Dacă-s cumincior, noaptea mama mă sărută. (brusc, nu mai citeşte) Ţin sărutul cu mîna pe obraz. Ţin cît pot eu*

de tare. Și sărutul intră-piele. VICE: "Mă râd" nu e bine. "Mă sar" e bine. CRISTA: "Mă sar" e greșit! ... "Mă mîngîiește", așa se spune!. VICE: Fără "mă"! ... "Mîngîiește" doar! TONTO: Tu nici nu mergi la școală!! ... De unde știi cum e corect?![6]

The entire short scene brings into view not only how these kids are invisible to the system, but also how they "learn" without knowing the basic difference between what is right from what is wrong. The tragic reality expressed in this scene is that the assignment was fairly easy, i.e., asking students to complete sentences. It becomes more and more evident that the incompleteness is a sign of something deeper and more problematic than doing homework. Whether or not someone will be teaching these kids how to use reflexive verbs correctly, that is of a lesser importance. Also brilliantly captured is the absent-minded TONTO who ignores CRISTA's questions until VICE kicks him under the table. When that happens, TONTO stands up involuntarily. For a few seconds, he does not even realize that he is not in school where, unfortunately, he must act rigidly, but he is with his siblings in a space where he should feel relaxed. His body language is just as relevant as his mechanical act of reading is, and this short exchange alludes to disciplining someone's body until it acts automatically, without thinking.

Interestingly, TONTO wants to break free; he lets us know why this homework is a reminder of what he does not have. Helped, he may complete these sentences, but he cannot have his mother in the room, and he does not want CRISTA to fulfill that maternal role. His gesture of pressing hard on his cheek is devastating. We also discover that VICE took matters in his own hands by quitting school and taking an indefinite hiatus. He does not know much either. His literacy level is the same as TONTO's, his younger sibling. The system failed him years ago, and now he is an *incomplete* teen in a society that does not know how to protect and invest in its kids' well-being.

Thus, what is fascinating in this play is to witness an *inverted* intersectionality. With their mother gone, with a female child "playing" the role of a surrogate mother, we observe what happens when motherhood is assigned irresponsibly to someone who *cannot* possibly fulfill that role. We may anticipate that the kids will embody the effects of their trauma of separation for the rest of their lives. The love and protection of a parent is irreplaceable and

Michailov introduces vulnerable children on stage whose future is considerably altered. Yet, she also speaks about the huge responsibility that we assign to women who are typecast in the role of the caregiver. We also notice how a country, ironically referred as motherland, is not ready to step in and fulfill this fundamental role in someone's development as a human being and thus ensure that kids are not deprived of interactions with a responsible adult. Not only is the mother gone, but there are also no social workers to step in immediately.

Point in fact, the next scene, *Spania, Spania, cutia este Mama mea!*[7] is a perfect segue into what we have just witnessed. The usage of the copulative verb creates a necessary discomfort. How could a mother be a box? What might the playwright be suggesting here? The fact that a box equals a mother says a lot about the parents' roles and responsibility in Romania. However, in this case, in her absence, her maternal love is transferred to a ... box. Unbeknownst to Michailov, the scene is reminiscent of a series conducted by the French born American artist Louise Bourgeois (1911–2010), *Femme maison*.[8] The artist depicted a woman whose face was replaced by a house, or her torso became a miniature house. In both examples, the woman is trapped. Bourgeois uses white marble to play with the idea of polished cleanliness and smoothed perfection, or what we ask women to achieve. In Michailov's case, the kids have literally received a box full of clothes and toys. The box is how the mother "communicates" (her love) *with*, *of*, and *to* her kids. How economical, to use one box and three prepositions to satisfy one irreplaceable (maternal) love! The scene is extremely short, and it ends with an "Ode to Spain" heard in the background: *Dă-mi părinții înapoi,/Spanio, mi-e dor de amîndoi/Să vadă copii-n clasă/C-am și eu părinți acasă./Să ne spunem noapte bună/ Și să ne teleportăm în lună./Să ne ținem strâns în brațe/Și să dăm chipsuri la rațe./Să ne plimbăm cu bicicleta/Să mîncăm sandvici cu brînză feta./Și o gumă huba-buba/Apoi să fugim în Cuba!/Să-nălțăm în parc un zmeu./Să mîncăm Mcfish mereu./De la City Mall să luăm clătite/Calde mari și rumenite./Să stăm tot timpul împreună/Să ne spunem poftă bună./Să nu mai plîngem în pernuță/Că stăm singuri în căsuță.*[9]

Another key moment in Michailov's play is meant to expose a system of education where students are not invited to use their critical thinking abilities. It is painful because I grew up in that system

and the current Romanian leaders disregard a solid involvement in education.[10]

Over the years, the playwright has been very vocal when it comes to using theater as a platform to bring kids and teens on stage and to verbalize their most ardent needs. As VICE says: *Mă pun să repet ca papagalu ce-am învăţat. [...] Scrie. De la capăt. Ce-am avut de pregătit pentru astăzi? Ai uitat. Nu ştiu. Repetaţi după mine. Repetaţi. Repetaţi. Repetaţi. Sînt un tun de litere şi cifre.*[11] Being denied individuality by a system of education is clearly emphasized towards the end of this episode by the *repetition* of the same verb. The ugly truth is that this is not an environment where kids are encouraged to ask questions, engage in critical thinking, but where they are a part of a system where one must memorize and later recite ideas to get a passing grade. Michailov accurately paints the twisted face of education in a country that appears to struggle on many levels. We do not face a war zone where families must leave the comfort of their homes behind, but a country that is not able to keep its citizens, pay them decent salaries, and let them be around their kids and friends. This is a universe of unimaginable, systemic abandonment: the kids are abandoned both by their family and society.

To make things worse, one classmate calls their parents *căpşunar*,[12] which is a denigratory neologism targeting those who work in strawberry fields and pick up the fruit so that others enjoy it carefree at their table.[13] *VICE: Părinţii tăi sînt căpşunari. Căpşunarii s-au cărat/ singur, singur te-au lăsat/ eşti un prost de toţi uitat. Căpşunari, singur, căpşunari, singur. Doar asta aud. Uite-l pe căpşunar!*[14] Not only does this character feel alone, useless, conflicted, but he is also made fun of because his parents work for financially poorly compensated seasonal labor in another country. The teen feels exposed and vulnerable. VICE does not want to go to school anymore because he is bullied and reminded of his constant humiliation. What he does not know is that without a high school diploma it will be even more difficult for him to find a decent job, and so, he may fall under the same pattern of having an insecure future, like his parents. Therefore, one question that readers may ask is the following: Is debt and/or lack of opportunities somewhat *inherited*, akin to heritage?

Michailov does not give an answer, but maybe that is her way of assigning us homework. What we get from *Offline Family* is

the constant disconnect that these kids experience. Later in the play, these kids receive a phone call from their mother, who is overwhelmed by the questions she is asked. We never hear her voice. She is absent and Michailov wants to make sure that we do not hear her at all. By not witnessing anything that she says, the mother appears to be completely absent from these kids' lives. Their curiosity and need to find answers are natural, analytical urges. *TONTO: Mamă, sînteți în aeroport? CRISTA: Mamă, fii atentă, ți-am zis că-s domnișoară? DODI: Mama, quero Ricci, una historia con pesci! CRISTA: Mamă am început engleza. TONTO: Mamă, ai putea să-mi aduci niște pastiluțe să nu mai fac atâta caca? TIBI: Mamă, dar n-ați zis că veniți? Și eu ce le spun? Cum nu știți când? Da, mamă, dar ei nu-nțeleg toate astea! Bine. Bine, mamă. Aveți grijă și voi. Tibi aruncă telefonul mobil. Se trântește pe pat și zapează la TV.*[15] The parents are not coming back any time soon; they will not return in time to be with their own kids and watch them grow up. The parents cannot *afford* that. While the father is asked only once about his return, the mother is grilled with many questions. She is the one who is *let inside* her kids' needs and developmental milestones. The father is practically non-existent, literally offline. Even if the mother is far away, she maintains her role as a confidant.

The play continues to present this household in disarray with kids who are growing up while losing their childhood prematurely, with holes and scars that are emotional, thus invisible, and more difficult to "cure." The play ends with a lullaby that is sung bilingually, in Romanian and Spanish, respectively. The children fall asleep without being consoled. Is there anyone who cares for their needs uninterruptedly? *Cântec de leagăn: Somn ușor, frățior,/Șapte purici pe-un picior/Să crești mare și voinic/Să n-ai grijă de nimic/ Lângă tine noi vom sta/Și te vom veghea.*[16] The play ends with *a veghea*, a verb that means "to watch over." The kids portrayed in this play will go to sleep and continue to live their lives in poverty, with distinct, harsh memories of what their family is. Furthermore, they will feel the burden of a trauma that is unending, and of a fractured image of what a family has been for them. Therefore, the whole system is off: parents who leave their kids behind, kids who can't make sense of this mess, an education system that erases their intellectual potential by asking them to memorize outdated materials, and a society that refuses to pass laws where kids must

be protected no matter what. The sad irony is that, in a patriarchal, religious, and heteronormative country, Romanian authorities only claim to care for families. Beyond that, there are many children who end up being institutionalized,[17] and, in some unfortunate cases, victims of human trafficking.[18]

In Their Own Words

Back in 2008 I was watching many documentaries about parents who must leave Romania to work menial jobs. I still remember vividly a teen, no older than 14 years old, who looked after his siblings. They were all living with their ailing grandfather. Not only do these families go through the intense trauma of family members being separated, but the state does not find ways to curb this tendency and to provide jobs and therapy sessions for all involved in such devastating situations. On a personal note, I am deeply invested in theater for kids and teens because it lets them understand harsh realities via theatrical tools that soften and inspire equally. This kind of theater, if done correctly, is meant to break down all or as many stereotypes as possible and replace them with new worlds and aspirations so that kids and teens realize there are possibilities and what happens on stage could be introduced or, even better, reintroduced back into society.

The most significant moment for me is when Crista, age 12, has her first period. She is alone during this crucial moment of her life and not adjusted mentally, even though her body tells her differently. She is not ready to become a young woman because no one has ever told her anything about this. This scene raises these questions that must be discussed publicly: What happens with teens like Crista who have never been told about their menstruating bodies? Who should assume this responsibility?

One of the most important subjects that the Western countries should be aware and respectful of is the huge detrimental consequences that the work migration has on people from Eastern Europe.[19] Not only do these humans accept poorly paid jobs under questionable conditions, but they are also dehumanized by the citizens of the respective countries as if their lives had no meaning. Thus, I'd like the audience members to reflect on this disruptive experience that affects in the long run not only the kids, who do not have the adequate skills to cope with this trauma, but also the

adults since addressing harsh and sometimes inhumane conditions is not encouraged in Romania, and, sadly, that is not even a part of these temporary working contracts.

If we look at the play from Crista's perspective, then we realize that she enters her maturity forcibly and prematurely. Both her body and brain are severely impacted by this traumatic exposure, and she will be carrying with her the imprint of this trauma into the next generations – if, later in life, she chooses to become a mother herself. I wrote this play in 2008, but now it is 2023, and we have not been able to talk about important concepts in which equity is of utmost relevance.

Back in 2008, Romanian literature did not have enough feminine voices where the focus was on teens entering their adulthood, sexuality, social roles, etc. I wanted to create this play and use it as a platform for a civic dialogue on issues that must not be perceived as shameful.

To me, intersectionality is a personal choice of not only seeing the problems but also talking about them in public spaces. Intersectionality is fundamental when we talk about injustices because we realize their deeper roots. After years of political indoctrination in communist Romania, it was true back then and it is still true now that we must use the great lessons of the Occident and implement them here. For example, the freedom of expression and intersectionality and the health of our communities should be addressed in literature and outside of it.

Activities

1. Visit a hospital, a hospice, a homeless shelter, or an orphanage, and do that for an entire month. Volunteer there for a few hours weekly. Keep a journal. At the end of your month-long journaling, give a presentation about your transformative experience. Please make sure that your written response/presentation is enhanced by examples coming from your interactions with people directly affected by their respective life circumstances. *Insert* their voices into your writing. Even though we may not have access to their lives and experiences fully, nonetheless we may have access to speak on their behalf and thus make their lives matter. The goal of this activity is to transform it into a Ping Chong type of dramatic writing.

2. Find one synonym for the verb "to abandon." List five sensory reactions to it. Create a "menu" for an improvised "drive-through" performance where your five sensory reactions serve as (ingredients for) dishes.

Notes

1 "Poverty Drives Central Europe's Great Exodus" by Ioana Patran: www.reuters.com/article/us-europe-population/poverty-drives-central-europes-great-exodus-idUSBRE82S08N20120329
2 Watch out!
3 Sometimes, Dr. Michailov uses the writing system before 1989 where words like *mână* (i.e., hand) were written by using "î" instead of "â." Similarly, she uses *sînt* (i.e., they are) instead of *sunt*.
4 CRISTA: I just don't know what else to do. I lost control over these kids. VICE: Idiot! CRISTA: I'm going to tell on you. VICE: Yeah, right. CRISTA: Well, mom should know. VICE: I thought you were mom. CRISTA: Come on, mom-mom! VICE: We don't have one anymore. CRISTA: But we will ...
5 Welcome to School!
6 CRISTA: Tonto, did you finish your language arts homework? Tonto?! What was the homework?! BUNICU (*Speaks very fast while the others cover their ears with their hands*): Mișu has seven roosters. Toma is with Lică. They are on a raft. The water is cold. Lică is a fisherman. He caught a carp. A pheasant has brightly colored feathers. Pepper. Tree. Child. Sorina has nuts. CRISTA: No, you, grandpa. Tonto, did you finish your language arts homework? Tonto?! What was the homework?! TONTO *does not answer*. CRISTA *repeats the question*. VICE *kicks him under the table. Suddenly*, TONTO *stands up, takes his notebook, and starts reading mechanically*. TONTO (*Reading*): "Finish up these statements: Dot, dot, dot and mother sees me." BUNICU: "Dot, dot, dot... and Romică has pears. We live in our country, Romania." CRISTA: Not, you, grandpa! TONTO (*Reading*): "I laugh me, I stand up me, I go to school me, I do the homework me and mother sees me." "Dot, dot, dot, mother gives me a goodnight kiss." (*Reading*): "If I am sort of good, mother gives me a goodnight kiss." (*Stops reading*) I put my hand on my cheek. I press it hard. And the kiss enters my skin. VICE: "I laugh me" is not correct. "I stand up me" is correct. CRISTA: "I stand up me" is wrong. "She caresses me," that's how it's correct. VICE: Without "me," just caresses. TONTO: How would you know? You do not even go to school.
7 "Spain, Spain: Our Mother is a Box."

8 "My Life in Art: The Day Bourgeois Moved Me to Tears" by Will Gompertz, www.theguardian.com/artanddesign/2008/oct/07/louise. bourgeois
9 Give me back my parents,/ Spain, I miss them both/I want kids in my class to see/That I have parents at home./ I want to say and hear good night/And then journey together to the moon./ I want to hug and be hugged/ And feel together our ducks./ I want to ride a bike/ And then stop and eat a feta sandwich./ Then I want a Hubba Bubba gum/ And together to go to Cuba!/I want to fly a kite in a park/ And always eat a Mcfish./ I want to buy crêpes from a mall/ warm and rightly cooked./ To eat together/ And wish one another, Bon appétit./ Thus, we could stop crying to sleep/ All alone in this house.
10 In 2016, President Klaus Iohannis (1959–) launched a program aimed at improving education in Romania; however, its implementation has been rather controversial and delayed by corruption and old mentalities. www.romaniaeducata.eu/despre/
11 VICE: In order to get a passing grade, I must repeat verbatim what the teacher taught us. [...] Write. Write again. What was today's lesson about? Did you forget? I have no idea. Repeat after me. Repeat. Repeat. Repeat.
12 The word for strawberry in Romanian is *căpșună*; the neologism is not only offensive, but, sadly, a consequence of the reality of cheap workforce. An interesting article pertaining to similar labor conditions in the US is "Human Rights Abuse in Plain Sight: Migrant Workers in the US," www.aclu.org/news/national-security/human-rights-abuse-plain-sight-migrant-workers-us
13 "Female Romanian Migratory Labor in Spain" by Sanja Davidovic, https://tinyurl.com/yzxhnhxz
14 VICE: Your parents are *căpșunari*? They left you. They left you alone. Now you are by yourself, no one cares about you. Do you know that this is the only thing I hear? They nicknamed me *căpșunar*.
15 TONTO: Mom, are you at the airport? CRISTA: Mom, listen carefully: Did you know that I am woman now? DODI: Mom, quero Ricci, una historia con pesci! CRISTA: Mom, I have started to learn English. TONTO: Mom, could you bring me some pills, so my diarrhea stops? TIBI: Mom, you said you'd come. So, what do you want me to tell them? What, you have no idea when you come back? Listen, mom, they can't understand all this. OK. OK, mom. Take care. TIBI *throws the phone. He turns the TV on.*
16 Lullaby: Sleep tight, little brother, / Seven fleas on your leg,/ May you grow up big and strong, /Do not worry about a thing./ Little brother we will be next to you/ and we will be watching over you.

17 A Romanian non-governmental organization that takes care of children without family is S.O.S. Children's Villages. The organization relies exclusively on donations from benefactors.
18 "2021 Trafficking in Persons Report: Romania," www.state.gov/reports/2021-trafficking-in-persons-report/romania/
19 Sadly, this unfortunate scenario is a global reality.

9 Exile Is My Home (*Exilul Este Casa Mea*)

Domnica Rădulescu

About the Play

With such a provocative title, exile appears to be tamed, while at the same time, home becomes less contained in one specific place on a map: exile becomes home, and vice versa, and there is a lot to be explored in this duality. It helps to note that the second title of the play is "A Sci-fi Immigrant Fairy-Tale," which happens in a dystopian present with flashbacks from the past, and in an intergalactic space, three different planets, and Planet America. Dr. Rădulescu came to the States before the fall of communism and she shares with her own mother a passion for literature, creating and consuming it equally. Before we read any lines, the academic turned playwright tells us that "The play follows the journey of Mina and Lina through different planets and countries in search of a home." Throughout their journey, each carries a miniature house that unfolds conveniently whenever they want to settle somewhere for the night. The house becomes something tangible and portable. She makes us aware that just as we can carry a home inside of our bodies, we can also imagine home to be foldable, and thus the concept that is central to immigration narratives becomes more easily digestible. The first exchanges are brilliant in continuing to create less tension around a word that is deeply rooted in randomness. We are born in one place; however, we never choose it.

Like incantations recited in the past, we should try to say this line several times until it feels real: a birthplace is random; a birthplace is random; a birthplace is random. *LINA: I was born in exile. Where were you born? MINA: I was born on the way to the market.*

DOI: 10.4324/9781003047711-9

96 *Exile Is My Home*

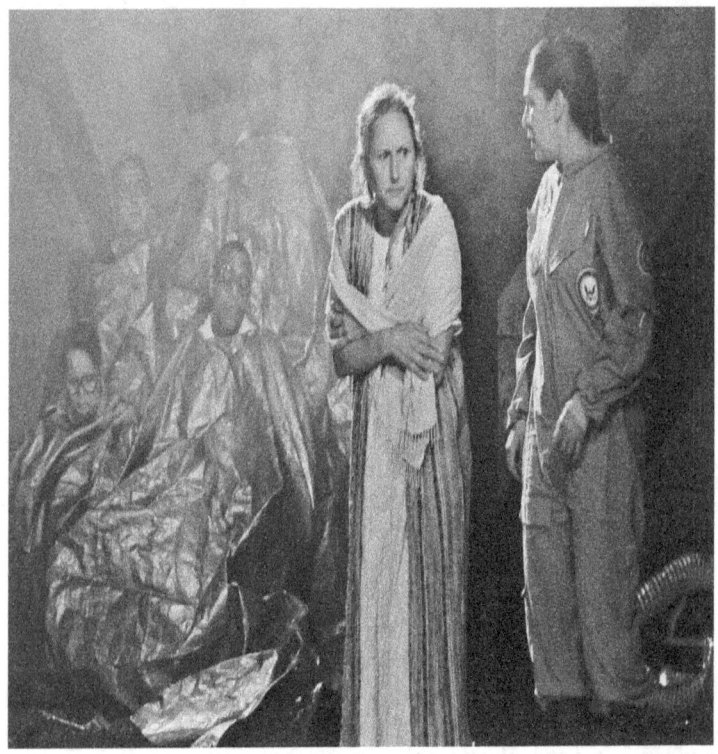

Figure 9.1 Image from performance. Director: Andreas Robertz. Theater for the New City, New York, U.S.A., 2016.

Reproduced with permission from the playwright.

LINA: *Oh, that makes sense then, that's why we get along. Why we sort of get along. In any case, it's better than with the others who were born somewhere precise.* MINA: *I know, people who were born somewhere precise are always such sticklers for geography. They say things like I was born in a little town in the country of Vdansk or the country of Smolensk, in the big city in Chesterbester, in a small house, in a big house, in a house with a big yard with a cherry orchard* ... LINA: *I know what you mean, blah, blah, right? I was born here, I was born over there, I am the son/daughter/sister/brother of so and so in the Textile Industry, of so and so at the Factory of*

Paintbrushes. Good for us that we were born in the air.[1] Rădulescu sets the tone for her play not only to make those who believe in jingoism that that is a dangerous reality, but also to open up discussions on what home is or should/could be. That is not to say that these characters have a care-free life; on the contrary, they are still searching for their home, alluding to the never-ending process of identity. *LINA: I remember a pond. A blue pond with a red flower in the middle. I was very little, and I had a mother and a father. They were not house carrying people like we are, and they had a regular house with a foundation in the ground and all. And a small potato garden in the front. My mother had always said I was born by the side of the road. After she gave birth to me she put me in her bag and carried me around for a while until she met my father and he built her a house with a foundation and a potato garden and a blue pond with a red flower in the middle. MINA: That's a nice story Lina, I never knew that about you and your family. My mother dropped me on the way to the market in another country, as she was going to buy fruit. She crawled in the desert with me in her fruit bag right after she had given birth. She wanted to say I was born in the country of Lugubria, so when she came into the town and went to the authorities to say she was asking for asylum from bad people in her country and produced me out of her bag of fruit from the market together with guava and oranges, and said "I just gave birth to this," everybody was stunned and said I was a country citizen right away. My mother was so happy that she died on the spot.*

The connection among these women, motherland, and their own mothers is something that we must read several times before continuing to read the entire play. In LINA's origin story, her identity is related to land and water, to a place where potatoes grew, and a pond had a red flower in the middle. That flower could be a symbol of the navel and the strong liaison between an infant and their mother, or it could be a singularity that signals the undeniable uniqueness that each and every one of us possesses. By contrast, MINA's origin story hints at those individuals who do not get to fully engage with a land, its people, and their traditions. MINA seems to be the archetypal wanderer, and that is the most fluid of all possible identities. Moreover, the first lines of the play revolve around two key words, *to be born* and *to remember*, respectively. This creates the perfect invitation to make us answer these questions, too. Whenever I teach this play, we spend an entire class

time talking about this dialogue, and we also complete an origin story in which we start from a real place as written on our birth certificate, but then we diverge from that, so we consciously stretch the experience of birth symbolically and thus remove it from a specific place. We most certainly will continue to talk about diversity and inclusion, but until we are ready to depart from specificity, we stay rooted in an old perspective in which the GPS coordinates match an almost stagnant geography. That gives us a sense of direction, but in the long run, it is a perpetuated illusion of belonging.

How could we then talk about progress if we do not emancipate the perspectives on our lives? MINA is shown with pride by her mother, and she is taken out of a bag, the birth happened, and she is here – and all the other details are irrelevant. Furthermore, because there is not a clear attachment to identity, because these women have a portable home, they can travel without restrictions to places that are far away where they must do specific tasks. For example, on their first stop on the Planet of Living by One's Principles, they decide to populate it because there was a terrible war. *GIRL ON FIRST PLANET: So, what can you two do? [...] Our planet is a little depleted right now from a recent war we've just had. The men on our planet decided to kill each other on account on the sizes of their penises. Lina and Mina make sure this planet will not go extinct, and they offer their bodies to let themselves being impregnated.* With Rădulescu, sometimes words are intentionally ambiguous. When she talks about "a recent war," she does not refer to a specific one, but to a machismo that controls a country's population via extreme violence putting an entire planet in danger just because of a stupid competition. This exacerbated, testosterone-driven ego suggests that, while in the play the reason is easily altered to create a maximum absurd effect, when that is juxtaposed to life, the question of why wars start, why they produce so much misery and so many casualties, then we realize that they are another lethal male egotistic competition. These two women who are visitors, *outsiders* of this planet, make time to heal it, and by their gesture, Rădulescu alludes to women and their nurturing, selfless trademark qualities. Moreover, the girl from the planet that is almost extinct realizes that there is something in her own identity that she was never able to fully decode. *GIRL ON FIRST PLANET: My grandmother was from a Balkan country somewhere in the Carpathians. I am the first generation born on this planet. And*

she used to always sing sentimental Balkan songs to put me to sleep. They made me yearn for something, but I didn't know what.

Not wasting time, Rădulescu tells us to think about the invisible ties that we might have with another, therefore, labeling anyone foreigner/outsider is a practice that should be discontinued. MINA, a character who tries to push herself to think beyond strict categorizations, has a clever retort: *See, that's the problem with memory and storytelling: it makes you yearn for the past even if the past was shitty and it makes you want a home. I think homeless is better. I think exile is better.* This happens early in the play, so Rădulescu creates another conundrum and lets us find its answers. Is being homeless better? What about exile? With a comparative added in the phrasing, then "better" must be continued to complete the statement. Thus, better *than* what? Since the playwright or her characters do not give exact answers, we can insert them as we please, even though we must be careful. After all, a(nother) war could start if we give an answer that may displease those in power/or with access to weapons of mass destruction. The first act ends with the two women having successfully repopulated the planet they were visiting. *GIRL ON THE FIRST PLANET: Bye-bye Mina and Lina, don't forget us, remember you always have a home here, whenever you are tired of sleeping and traveling in your flower house, whenever you are tired of sleeping on the side of the road and living in exile, come back to us and enjoy our round city and our healthy bodies.* They continue their adventure, and the second planet they visit is a place where people consume their homes/landscapes. Their role qua passengers through this place seems more evident here. The play on words is generated by the duo "yearn" and "remember." *LINA: What kind of planet is this, Mina? Look at the red flowers coming out of the desert, it all looks so yummy, I want to eat it. Maybe we have found our home. Maybe this is the planet where people eat their surroundings. No need to shop for food and cook. No need to worry about the antibiotics in the milk and the cheese. You just walk through the desert and eat red flowers. I'm tired of homeless. I'm tired of our stupid little folding and unfolding houses. I want a Balkan song. I want a place of my own that I can eat and where I can feel its sweet juices fill my mouth. I want my mama.*

Literary scholars and readers could easily trace the idea of eating something as generating an internal, sensory journey.

Instead of the magic carpet, Marcel Proust created a malleable madeleine that can effortlessly change, given one person's memories. In addition, here we find a character that goes by a generic title of GIRL ON THE SECOND PLANET, who also yearns. This character offers a glimpse into the other part of immigration where one is born in a country that, on paper, looks ideal, but in reality, has serious, hidden issues. As she recounts: *I was once living in that imperialist country, Planet America, and I thought I was happy living there amidst ponderosa pines and dry gulches in the Wild West, a perpetual Western movie fantasy. Until one day when a man with a gun, when two men with guns, when a thousand men with guns ... And I had had enough of the whole Western crap. I decided to immigrate and leave everything, ponderosa pines and all. But sometimes I miss it. Sometimes I yearn for it so badly I have to ride these bicycles over all the cliffs on the planet and concuss myself into oblivion. So, then I decided to do the constant theater thing, the playing of parts, of the world's best theater repertoires. It works, this is how we populated our country. We play and play until we forget our identities and yearnings. Want to join in, want to immigrate? There are many advantages, plus, here almost everything you see is edible, even the bicycles are edible. They are made of marzipan, and if you leave them in the sun they start melting and they are delicious.* With Rădulescu, then, the topic of immigration is deeply woven into topics of birth, place, choices and circumstances – and no character seems to have an ideal life; in fact, each yearns for something.

As we continue to travel alongside the protagonists, we go to the next stop, on the third planet which is titled The Snow Planet, Snow White, where we meet WOMAN WHO EATS HEARTS. During this stop, we also meet BILLY, who is the main protagonists' long-lost son. Moreover, it is revealed the reason why this man was separated from his family. When a war suddenly started, he was kidnapped. Rădulescu adds yet another layer to immigration by exposing the most vulnerable of the victims – those without or little agency, whose lives may be exploited even more selfishly. The fact that these women forgot they even had a son is probably one crucial aspect of their development as characters. They need not to be judged. MINA and LINA forgot they had a son because they are still scarred by wars, and, intergenerationally,[2] they seem to be carrying inside their DNA a yearning for a stable existence

that is denied to them. This journey is more to fulfill that void than we thought originally. In other words, it is not only about finding that place that should match their yearning, but also about a journey of exposing the ugly truths of treating people violently, denying them their human rights. BILLY: *Mamas, look, look, I can make the boat float, it's floating, it's moving. It's going to China.* YOUNG LINA AND MINA: *That's wonderful sweetie. So proud of you! Billy, sweet Billy our dear Billy goat.* BILLY: *Mamas, why do boats float?* LINA: *Because they have to take people from one shore to the other. They are a means of transportation. They go to China.* MINA (*Laughing with endearment*): *Oh, listen to the urban planner in you. Boats also float because they add fluid beauty to the world, because it's more fun to float than to walk or drive. And because they must save Ophelia.* BILLY: *Who is Ophelia, mamas?* MINA AND LINA: *Ophelia is, Ophelia was a girl who ... [...]* BULGARIAN ORGAN THIEF 1: *You tell us where you hid your creep of a son, or we'll carve out your little kidneys and livers like you carve a pig for Christmas.* BULGARIAN ORGAN THIEF 2: *Yea, that's right you, bitches, we can get ten grand for a kidney these days and the double of that for a liver. They're in high demand.* MINA AND LINA: *We don't know.* (*Sounds of hitting and torture in the dark. Sounds of both younger and older Mina and Lina crying and begging for mercy are also heard*). *We don't know, we would tell you if we knew. He was taken away from us. You should know.* The dialogue about boats could lead to three potentially interesting topics that range from their practicality, aesthetics, to theater, until Rădulescu almost without any solid breaks swerves into an inhumane reality of displacement where people may end up paying for their lives with their own. While this may sound redundant, it is a reality that must shake us to our deepest core.

The three characters, BILLY and his mothers, are finally together and instead of instant manifestations of joy, everything is confusing, and it signals the long effects of displacement and extreme violence. Their reunion is not fully enjoyed because they are not even remotely healed, and thus, we must accept the rambling part that happens next. BILLY: *You are not dead mamas since you travelled all the way here to this planet to save me. You did travel all this way to save me, right?* MINA (*looking confused, disconcerted, not knowing what to say*): *Yea, sure sweetie, of course...* LINA: *... we travelled all the way here looking for you.* MINA: *Are we Croatian?*

LINA: *I don't know, I thought I was Finish and you were Polish.* MINA: *I thought you were French, and I was Hungarian.* LINA: *Was there a war?* MINA: *I think so. A Balkan war.* LINA: *Was it Bosnia, Serbia, Croatia, Slovenia?* MINA: *Or was it Slovakia, Montenegro, Macedonia?* LINA: *Romania, Bulgaria, Latvia?* MINA: *Was it Balkania?* LINA: *Was it Blinia?* MINA: *I think it was Blinia. There are always wars in that part of the world. They fought over Blinis, cheese, potato, and marmalade Blinis. That's why the war started.* MINA: *In another country it started because of the penis size.* The audience is subtly invited to test their knowledge of geography, and consequently to see if they recognize any of these "small" countries. Rădulescu puts Eastern Europe on the map, and if these countries are forgotten (*sic!*), she wants to say and let us hear their names one more time.

Apparently, Eastern Europe *had*[3] to represent the Communist bloc; our lives under communism were so deprived when compared with the citizens' lives from the other "half" of Europe. Partly, if we act in an idiosyncratic manner, that is because of these inequalities that were deeply felt beyond the Iron Curtain. Moreover, when the communist regime ended in this part of the world, and it was replaced with democratic principles, we had to witness yet another reality: we had to see how some people were amassed to belong to a country (like those in former Yugoslavia), when they should have had their own distinct motherland depending on their native tongues/idioms, rituals, etc. This aspect caused ethnic rebellions,[4] and, in return, it postponed the healing of these people's identities. It is difficult to put into words how restrictive our lives were during communism, and it is even more painful to realize that some people's motherland was not even theirs but determined rather chaotically by *male* political leaders.

So, by the time we arrive to the fourth planet, Planet America, we have already been introduced to remembering, yearning, war, displacement, ethnic division, and trauma. IRRITATED IMMIGRATION OFFICER: *Obradovskapopovicimanton family. Is this a real name you people? How can you get through life with such a name?* MINA, LINA, BILLY: *Yes, here we are. That's right here we all are. The Obradovskapopovicimanton family.* IRRITATED IMMIGRATION OFFICER: *Hm, let's see, papers!* LINA: *Papers? What papers? We've come here for papers.* IRRITATED IMMIGRATION OFFICER: *Immigration papers*

you stupid dykes. MINA and LINA: What did you say? IRRITATED IMMIGRATION OFFICER: You heard me. MINA and LINA: No, we haven't heard you. Please repeat. IRRITATED IMMIGRATION OFFICER: All right then (Shouting so that everybody hears.) The immigration papers you stupid dykes. Everybody turns and stares at Lina and Mina at the same time almost in unison. IRRITATED IMMIGRATION OFFICER: Did you hear me now? Later, using and abusing his power, he has the following moment: *IRRITATED IMMIGRATION OFFICER: First you are deported and second you are executed on the border. To give a lesson to all those who cross the border and yearn, and vandalize, urban plan and make babies on trains and escape and escape ... Our borders must be safe, we have to secure our borders, our cities, our homes and our drawers. You can't be safe anywhere no more these days because of you scum immigrant people with no papers, with no papers and obscene names. Obscene names!* It could be argued that IRRITATED IMMIGRATION OFFICER acts like this because of the "nature" of his job. But that is an old and defective defense, especially nowadays when we have been pushing to fight *for* inclusion and diversity. The most blatant aspect of his harmful behavior is when he does not realize that being an American implies unequivocally that "his" origin story is the epitome of layers of sedimented naturalization. To prove her point, Rădulescu could have easily chosen him a specific name, but, as noticed, she names only three characters in this play: LINA, MINA, and BILLY, respectively–and that is not accidental at all.

As we advance towards the end of the play, Rădulescu knows too well that a solution to a decent immigration set of laws is not yet available, so what could we do? She wants us to reinvent what we mean by home. *MINA: Our home will be sweet and small. LINA: Our home will lack nothing at all. BILLY: Our home will have a fruit market and a tiny mall. MINA: Our home will be round as a ball. [...] TAXI DRIVER FROM UZBEKISTAN: We'll bake bread that is crunchy and blonde. GAUTEMALAN MASSAGE THERAPIST: We'll weave colored quilts from here and beyond. LINA: We'll tell our story the worldwide. MINA: We'll live in the desert, the city, the east side. BILLY: And we'll always look on the bright side. [...] MINA: Oh, it's good to be home. LINA: Honey I'm home. BILLY: Let's go home. GAUTEMALAN MASSAGE THERAPIST: I wanna go home. MINA: Honey, come home. GAUTEMALAN MASSAGE THERAPIST: What a nice*

home. *TAXI DRIVER FROM UZBEKISTAN: I'm at home. GUATEMALAN MASSGE THERAPIST: Home sweet home. MINA: Make yourself at home. LINA: There is no place like home. BILLY: Home is where my heart is. That really brings it home. MINA: Home is the place where, when you have to go there, they have to take you in. LINA: I want to stay home.* Therefore, Rădulescu offers a sample of how we could use the noun home in a way that shows emancipation and respect. The play has reached its end. We put the script down. What does home mean to you?

In Their Own Words

There are several sources of inspiration to my play *Exile Is My Home*: my own experience of having escaped my native Romania in the eighties and having settled in the United States as a political refugee; the many stories of refugees that I have heard or been close to and that have imprinted themselves in my memory; my intensive research of the genocidal war of the Balkans in the nineties and the mass extermination and genocidal rapes of Muslim Bosnians by Serbian armies, the interviews with survivors I had in Bosnia; my turbulent imagination that has assimilated stories, memories, images of loss and violent displacements and has churned them into a fantastical tale that is at the same time rooted in some of the darkest realities of our time.

My favorite part of the play is the third Act, White Planet, Snow Planet, because of the revelations in the characters' lives that it unfolds, because of the combination of moments echoing sinister realities of genocides, violence against women, human trafficking, drug addiction, and an ethereal atmosphere.

I want my audiences/readers to be troubled and bothered by the realities illustrated in the play while equally to distance themselves in a Brechtian way and think through these realities, be transformed, acquire an understanding of the experience of exile, and wonder how they can themselves act in the world and contribute to social justice.

My own brand of feminism is illustrated primarily through the two leading protagonists Lina and Mina who are valiant heroines and travelers through dystopian worlds, as well as creators of new worlds, initiators of change, storytellers and action heroines who save the day and the world. The play proposes new ways of

being in the world, based on female collaboration and sisterhood, inventiveness, and inclusivity.

Through the characters of the play that embody many races, ethnicities, backgrounds, and sexual orientation, by means of dark humor that denounces and derides racism, homophobia, misogyny and xenophobia, the play offers diverse experiences, discourses and realities that break with the monolith of white patriarchy.

I think of intersectionality as the crossroads of patterns of discrimination, as well as the crossroads of possibilities to implement and embody diversity. Lina, Mina, their son Billy, the Guatemalan Massage therapist, the Taxi Driver from Uzbekistan cross and overcome multiple obstacles created because of hatred, ethnic violence, racism and homophobia only to emerge above it all like fairy tale heroes through the power of their imagination, solidarity, and love. They create utopian worlds where refugees are the heroes that save the day and sassy heroines dismantle patriarchy and create utopian landscapes of inclusiveness and belonging.

Activities

1. The playwright provided a brief translation in Italian of a passage from her play. With the help of any dictionary or (ideally) of a native speaker's perspective, in groups, read the selected passage aloud and choose a series of five words that may sound familiar, and another five that you have no idea what they mean. Then, find out what each signifies. Go back to the context and insert the translated words into the Italian version. Read the passage one more time. How do these words change the (now partly bilingual) reading and the meaning/understanding of the passage? What would happen if you replaced them with synonyms/antonyms? What might this activity reveal about communication when we don't know a specific language?

 L'Esilio e la mia casa: *Il primo pianeta. Vivere secondo i propri principi.*

 LINA: *Io sono nata in esilio. E tu, dove sei nata?* MINA: *Io sono nata sulla strada verso il mercato.* LINA: *Ah, questo spiega tutto. È per questo che andiamo d'accordo così bene, che quasi andiamo d'accordo. In ogni caso, è meglio di tutti quelli che sono nati in un luogo preciso.*

MINA: Lo so, quelli che sono nati da qualche parte di preciso, sono tutti pignoli per la geografia. Dicono cose come Io sono nata in una piccola città nel paese di Vdansk, nel paese di Smolensk, nella grande città di Chesterbester, in una piccola casa, in una grande casa, in una casa con un gran giardino e un frutteto di cigliegi. LINA: Sì, so cosa vuoi dire. Blah, blah, vero? Sono nata di qua, sono nata di là. Sono la figlia, il figlio, la sorella, il fratello di questo e quello dell'industria tessile, di questo e quello della fabbrica di pennelli. Meno male che noi siamo nate nell'aria. MINA: Da nessuna parte. LINA: Nell'aria. MINA: Se non fosse così scomodo vivere la vita nella strada, direi che vivere in uno stato di esilio permanente è la migliore casa che ci sia.

LINA: Siamo mai state stabili noi? MINA: Non lo so, che cosa ti ricordi? LINA: Non lo so, e tu che ti ricordi? MINA: No lo so, e tu che cazzo ti ricordi? LINA: Non devi fare la stronza. È assai difficile che dobiamo portare queste case sulle spalle come un paio di lumache fottute. MINA: Ricordo uno stagno. Uno stagno blu, con un fiore rosso al centro. Ero molto piccola e avevo una madre e un padre. Loro non portavano le case sulle spalle come noi, e avevano una casa normale con le fondamenta dentro la terra e così via. E con un orto di patate di fronte. Mia madre diceva sempre che io ero nata al lato della strada. Dopo che mi ha partorito, mi ha messa nel suo borselino e mi portava così dappertutto, finché ha incontrato mio padre e lui le ha costruito una casa con le fondamenta e con un giardino di patate e con uno stagno blu con un fiore rosso al centro.

2. Find an article about *immigration* and *motherland* and use it for a session of Newspaper Theater. Talk about the complex nuances between these two nouns. Ideally, publish an article in a local/national newspaper.

Notes

1 To the best of my knowledge, Dr. Rădulescu did not translate the play into her mother tongue. Consequently, this chapter's quotes will be in English.
2 "The Legacy of Trauma" by Tori DeAngelis: www.apa.org/monitor/2019/02/legacy-trauma
3 "The End of WW II and the Division of Europe," https://europe.unc.edu/the-end-of-wwii-and-the-division-of-europe/

4 "History of Ethnic Tensions": www.ushmm.org/genocide-prevention/countries/bosnia-herzegovina/case-study/background/history-ethnic-tensions and "The Conflicts": www.icty.org/en/about/what-former-yugoslavia/conflicts

10 Aliens With Extraordinary Skills (*Extratereștrii Cu Puteri Supranaturale*)

Saviana Stănescu

About the Play

From the start of her play,[1] Stănescu offers the readers a mix of characters and, by doing so, we have the feeling of the magnitude of possibilities, identity-wise, that existed, exist, and will continue to emerge not only in the United States, but (ideally) in the world, too. We meet NADIA who was born in Moldova,[2] BORAT who was born in Russia, LUPITA who is a Dominican-American, BOB who was born in the United States,[3] and two Homeland Security qua Immigration and Custom Enforcement officers labeled as INS 1 and INS 2. Stănescu does not say anything else about the time and setting of the play, as she delves directly into dialogue. The first scene is titled "A Deportation Letter" and we meet NADIA who is seen in her clown costume delivering joy to kids at a birthday party. The fact that she is in costume could reach deeper meanings. She is performing to get paid, that is a given, but she is also shielded by that costume. No one knows who the performer is. There could be good and bad consequences out of this detail. Good, because NADIA has her moments *suspended* from her uncertain reality as an artist working for an unknown period. When people read "deportation," even if they have not faced such a scarring reality, they may relate to when they think about an "evacuation" letter that some landlords post on renters' doors. Both words are said by humans to other humans, both make one's heartbeat reach accelerated rates. Bad, because NADIA is more than just a clown in costume; however, if/when she takes it off and starts to talk, she could be ridiculed, marginalized on account of her accented English.[4] The first lines set the tone for the play, and it

DOI: 10.4324/9781003047711-10

Aliens With Extraordinary Skills 109

Figure 10.1 Image from performance. Director: Tea Alagic. Julia Miles Theatre, New York, U.S.A., 2008.

Reproduced with permission from the playwright.

is important to note that they happen while she performs her duty at that party. In other words, these thoughts are silent: *Incision in Nadia's mind: INS 1 and INS 2 get closer.* Most likely, the officers are there, but even if they were not, we are invited to realize the damaged done by this type of invasive dialogues: *INS 2: Aliens are subject to mandatory detention. INS 1: If they fail to obey. INS 2 / INS 1: The rules. INS 2: Nadia Sacharov. INS 1: You received an official LETTER. INS 1 / INS 2: Last week! INS 2: That stated very clearly. INS 1: And politely. INS 2: That you must leave the country. INS 1: In two days. INS 2: Otherwise, you're subject to.*

INS 1: Expedited. INS 2: Removal. INS 1: Translation: INS 2 / INS 2: Deportation. The dialogue is short, but intense. The choice of words is inhumane, and the two officials treat NADIA as if she was not a human being. The few words that are uttered are not even full sentences because NADIA must follow orders, and she is not there to respond to "How are you?" but to comply to the pressures of a harsh interrogation.

Furthermore, even though Stănescu does not introduce any Romanian characters in her play, the first exchange is traumatic for those who knew about the intimidating practices done by *Securitate* in communist Romania. NADIA is at a birthday party, a joyous occasion, but the tone and perspective switch easily to a more official look into the United States. We are not given a chance to read the letter that was mentioned above, and Stănescu wants us to focus on one word only: deportation. The word can be traced back to Latin, *deportare*, from *de-* "away" + *portare* "to carry." Deportation also means to have something added on someone's permanent records that, unlike tattoos, stay there forever quite hauntingly. In fact, given the title of the play, NADIA is one of those individuals with extraordinary talents that the US seizes as important, but in her case, for whatever reason, these talents cannot secure her a permanent stay. For readers who are not as educated on immigration aspects, historically speaking, this process has its own stages. To research properly and without any bias, readers should probably look more closely into aspects such as how many types of visas are issued by the U.S. government yearly. There is no shame to admit publicly that the U.S. is a mastermind when it comes to how it attracts great intellect with wonderful potential because, invariably, the U.S. could profit and prosper out of these individuals' qualified work. These humans are given easier access into the whole immigration process, whereas NADIA is here for a limited period. Indirectly, Stănescu was referring to artists who are invited to the States for one reason only, that is, to do their job of entertaining the public. Partly, Stănescu was relying on her personal experience.

In addition, although there are other characters in the play, I would like to focus on NADIA almost exclusively because she is torn apart by immigration officers, a job that is not secure because of her temporary working visa, and, finally, because of something else that is going to happen later in the play. Right now, we are back

Aliens With Extraordinary Skills 111

to the interrogation scene, and in this case, the three of them face one another (that is, this scene does not happen in her head/has not yet been internalized). *INS 2: Do you have any fear or concern about being returned to your home country? INS 1: Or being removed from the United States? NADIA: I don't want to be removed! INS 2: How did you make your living in your home country? NADIA: Family business: The SACHAROV Clowns! We were a great team! I worked as a clown since I was 6. I learned English, French, German, I can be funny in all those languages! INS 1: Why didn't you go to Germany? INS 2: Or France? INS 1: You're hiding something. INS 2: Have you ever been convicted of a felony in your country or in America? NADIA: No! INS 1: Have you ever plotted crimes against the United States of America? NADIA: Never! INS 2: Have you ever taken part in terrorist activities in your country or in America? NADIA: God, no! INS 1: Have you ever made plans to overthrow the United States government? NADIA: I'm not a criminal! All I want is a normal life. INS 1: What is a "normal life"? INS 2: Why couldn't you have a normal life in Moldova? INS 1: What exactly is – in your definition – a normal life? INS 2: "Normal" – what's normal? NADIA: To live among normal people, harmless people, free people, happy people, to like your work, to be appreciated, to have a family, a husband... INS 1: You're saying you want an American husband? INS 2: Why do you want an American husband? INS 1: What's wrong with Moldovan husbands? NADIA: I dunno ... they are ... [...] Moldovan people are nice. Kind. Helpful. Beautiful. It's just ... INS 1 / INS 2: What? NADIA: I couldn't make them laugh anymore. They're too poor to be happy. INS 1 / INS 2: C'mon! NADIA: You must understand this! Don't send me back. I want to be like you, I want to be happy! It's written in your constitution. This country is about happiness. I know that! INS 1 and INS 2 start laughing. Scornfully.* Therefore, NADIA realizes that in order to survive, she must try to learn the "rules" of the game in which she has to find a way to entertain people legally in the States. Stănescu plays a lot on the risky, fragile, unfair world of the female entertainer because NADIA's situation is not exclusively hers, but it could, and it does in fact happen to more artists.

The entertainment world has a cruel side, and there are artists who cannot make it based exclusively on their craft and skills, so, they must resort to other professions and "reinvent" themselves. NADIA meets LUPITA with whom she shares a room in the

latter's apartment, and who also introduces the former to some questionable parties. NADIA still wears a clown suit with a small "change," that is, now, at these parties, her costume is a "very sexy clown costume," which foreshadows a deplorable, unpardonable abuse. *NADIA: What?!... I did it.... Yes... I went to a veeeery cool party. In Soho. Wall Street guys. Yes, fancy! All in expensive suits. And the women – in designer clothes, yes, like in "Sex and the City"! Perfect teeth. Perfect hair. Elegant. Stylish. Friendly. What?! I know I'm not one of them! I went there to work! To ENTERTAIN. I am a clown artist! I am somebody! What?! (pause) Everybody was... laughing, drinking, smoking... I learned new words in English: ganga, weed, pot, grass. Yes, drugs! They were smoking drugs, they were cool. INS 1 / INS 2: Drugs?! INS 1: You used drugs. INS 2: And you're proud of it. NADIA: I didn't know much about drugs. Mike noticed and laughed, he said: "she's a drug virgin." INS 1: Who's "Mike"? INS 2: Mr. Big? NADIA: Let me explain.... I get there I am soooo excited... My heart is pumping hot steams not blood... This guy Mike ushers me in. He is confident, elegant. He says: "Hi, pretty lady." He takes my arm. He introduces me to people. He tells them: "She's from the former Soviet Union". He prepares a drink for me. A cocktail. A Cosmo! Yeah... I drink, I smoke, like everybody else... I am cool... I dance for him, for them... I am sexy, I shake it well!... A few hours pass, I think... I get tired... My stomach is a bit upset.... But it doesn't matter, everything is too perfect... I walk into this room... Beautiful room... A bedroom with red-painted walls and huge windows... I can see the Hudson River... great view!... Red lights dancing on the river ... like mouths with bloodred lips, laughing in the river... I press my face on that window... My feet hurt from dancing two hours on spike heels... I take off my shoes for a moment. Just for a moment. I think I'm alone. I am not alone. Mike enters. He comes closer... I can smell his expensive aftershave... He's gonna kiss me! No. He puts his hand under my skirt... Strange... His face looks different... "Say something in Russian, Natasha!" He keeps calling me Natasha... "You, Russian babes, are all so fucking sexy" ... What is he doing?... His hand... His fingers... Pushing my underwear, pushing... "C'mon, Natasha! Say FUCK ME, Mike, in Russian, Natasha!" ... (pause) I had to run barefoot out of that room. Out of that apartment. Out... and I left them there... I left my shoes... I didn't have time to grab my Manolo Blahniks... Lupita will kill me ... and that's fine with me ... that's fine... I deserve that. (She*

sees a CAB) Hey, cab, cab, please stop, stop, please stop! I wanna go home. Home. NADIA recounts the incriminating moment of abusive behavior in quite vivid details, and we feel like we are with her in that room, observing how her surviving instincts kicked in, but how that is not going to be enough.

NADIA does not report the rape, and the playwright reminds us that she is an undocumented performer. However, if you realize that INS 1 and INS 2 were previously interrogating her, then they *knew* about her status and would have kicked her out without any hesitation. On the other hand, if those interrogations happen only inside her mind while she has been performing at birthday parties, then the scenes have dramaturgic holes. The conversation that NADIA has with LUPITA reveals other tough, quite strange realities. NADIA is *abandoned* in this scene, and it was very hard for me to continue to read the play. Raped, poor, insecure of her language, homesick, alienated in this culture, not knowing who she is anymore professionally, instead of being given support, when, if I am being perfectly honest, the character should have benefitted from immediate counseling, NADIA is attacked on all possible fronts: *LUPITA: Listen, girl. We cried together, we felt sorry for ourselves, we spoke about how shitty this world is and how we, the immigrants, get shit everyday... Enough is enough. Thicken your skin. OK, you got raped, it's bad, it's very bad, it's fucking awful, but you're not dead, you're alive and you got stuff to do... (matter-of-factly) Do you have abdominal pain or hemorrhage? NADIA: I don't think so. LUPITA: You don't think so or you don't have? NADIA: I don't have. LUPITA: You took the "morning after" pill I gave you, right? NADIA: Yes. LUPITA: OK. We're fine. No shit will grow inside your womb. You're OK with that, aren't you? (Nadia doesn't answer, any word about the rape hurts her) I knew this girl, Lena, a Columbian chick, she got pregnant after a rape and kept the child. The kid is an American citizen coz he got born here, so she's happy now, she got her green card. But I don't think you wanted that kinda stuff, did you? NADIA (doesn't want to talk about the rape): Can I have some cereals? LUPITA: Finally. She hands Nadia the bowl, Nadia eats so she doesn't have to talk. LUPITA: Honey... don't think I'm insensitive ... I'm not ... but we must keep going, that's all. We can't afford depressions and–how do they call it?–"post-traumatic stress" and other shit like that. Only rich people do. We can't afford to go to the shrink. We can't afford to ... (waste time on*

post-traumatic stress) NADIA: *I got your point. Please ... (shut up) (Long pause.)* LUPITA *(feeling guilty)*: *I'm gonna tell all the girls not to trust that shit who talked me into that Soho-gig... Criminal pigs, nobody will work for them anymore!*

It is not clear to me *why* Stănescu, when she *had* a chance, missed it big time. The Civil Rights Act of 1964, Title VII, talks about harassment, and how it is punishable by law. Even if LUPITA might not have been aware of all these legal aspects, even if neither female could have afforded to hire a *good* lawyer, and even if literature is interpretable, it is triggering for me to notice the lack of female solidarity, which I personally view as disturbing and retrograde. Factoring in the scope of this volume, if we make theater for the 21st century and beyond audiences, we, female identifying persons, must stop being afraid to stand up! We cannot even begin to talk about emancipation, let alone intersectionality, if a prominent voice such as Stănescu's doesn't stand up to fight *unflinchingly* against all types of abuses. Even more so, when we talk about rape,[5] one of the most invasive and traumatic experiences a human could ever endure, something that cannot be erased from their body/mind, there is *no* room for negotiation! Furthermore, theater, as a mirror of reality, must follow the same policy. While it remains a mystery why Stănescu made such a blunder,[6] as a critic, I'd be remiss if I did not signal this problem. That had to be said, so it is addressed in this volume and outside of it, and we do not diminish the value of the play but discuss openly the autonomous value of our female bodies!

The play ends how it begins, with NADIA performing at a party. The immigration officers are still there, another presence that cannot be erased, only that this time they do not have any lines. They wear "scary-clown masks." This could mean that they, ironically, show their "faces" via these masks, and this may be a reversal to how we typically perceive them. The fact that they do not say anything is probably even more intense, not only because that information is placed exactly at the end of the play, but also because when someone can talk but decides to choose silence that could be even more devastating. Before the officers appear on stage, confirming their undeniable presence in the play, NADIA says: *The dog and the squirrel got married and lived happily ever after. They are looking at the ocean from their home in Brighton Beach. They have dog-squirrel babies or puppies or puppirells or whatever you*

want to call them. They all have American wings now but they like to walk, in the evenings, with the whole family on the Russian promenade. Sometimes they stop and make tricks. Clown tricks. They are a family of clowns. They own a Birthday-Parties business! They have extraordinary skills in making people and animals laugh. They make people and animals happy. Woof-woof! Woof-woof! They are happy. They are. Everything continues as a big *circus*, and these individuals' extraordinary skills are not respected because their rights as citizens of the world are ridiculed. The play's end makes us think of *why* we consume entertainment, and how we could rethink our involvement so that it benefits independent artists/unrepresented ones. A fair exchange between artists and the public could be another way to address this play's messages, thus realizing its metatheatrical, social qualities.

In Their Own Words

I arrived in New York in 2001, two weeks before 9/11, and started to write in English as a graduate student in Performance Studies and Dramatic Writing at NYU. It hasn't been easy to start again from scratch, as a published and produced Romanian writer with Roma and Balkan roots who had achieved a certain notoriety in Romania and Europe in the 90s. After NYU, I got an O1 visa for "aliens with extraordinary abilities in the arts." I had to apply for that visa every year, for over 15 years, and to continue to prove that I am "extraordinary" and that I belong here, in the US. It's been exhausting, frustrating, and humiliating. In *Aliens with Extraordinary Skills*, I tried to capture that strenuous *in between* space where migrants dwell, the balancing act on the "hyphen" between cultures and the non-stop negotiation between the American Dream and the small (and big) daily "nightmares."

I think I love the Dreamscapes the most: in them, Nadia, the protagonist, is haunted by two imaginary Immigration and Customs Enforcement officers who tease and bully her, making her life miserable, reminding her that her role, as a poor immigrant clown/artist, is to keep a low profile, to entertain, to make herself pleasant, to serve others. It goes as far as a climactic moment in which Nadia endures sexual abuse at a party of rich people but cannot report it because she is afraid of getting deported. The INS/ICE officers are of course fictional characters, but I gave them

some lines that foreign people are asked in the visa applications or when they marry a US citizen.

Maybe because I was in the streets, as an idealist college student at the Romanian revolution in December 1989, and then I worked as a journalist in the newly created free press, I still believe in the revolutionary writer, the writer who's always on the barricades, fighting for the underdogs, pushing the borders of human knowledge and the understanding of the Others/Outsiders. Immigrants often experience that fear of not belonging, of being THE OTHER: a stranger, a foreigner with a funny accent, an alien from another "planet" who "doesn't deserve" to be in the US. I hope the audiences will get a glimpse into the daily life of immigrants/outsiders, the un/documented *aliens*, the global foreigners, and the non-conformist artists.

The female characters in my play are strong, resilient, yet vulnerable. Nadia, the newcomer, learns from Lupita how to be stronger. They both have to endure #MeToo moments of sexual harassment/abuse, but cope with them differently. Nadia learns the hard way that she doesn't have a voice and can't report the abuse as an undocumented immigrant. The solidarity and friendship between the two women are what ultimately helps Nadia to overcome challenges and move forward. I think Lupita's advice and support for Nadia, after the sexual abuse at the party, speaks volumes about my brand of feminism and its key words – women's solidarity, strength, and resilience. In Lupita's words: "Honey… don't think I'm insensitive … I'm not … but we must keep going, that's all. We can't afford depressions and – how do they call it? – post-traumatic stress and other shit like that. Only rich people do." I strive to create nuanced and complex women characters that challenge the stereotypes and empower women across the world to be who they really are.

If I am to reimagine the old Brechtian adagio "Art is not a mirror held up to reality, but a hammer with which to shape it," I'd say: let's shape our contemporary realities with a multi-racial queer she-hammer. I was raised by my maternal grandparents in the small medieval town of Curtea de Argeș, the first capital of Walachia, famed for its cathedral and the legend surrounding it: Manole's wife, Ana, was buried alive, inside the walls, by her husband. That was an iconic example of "the artist's sacrifice for his creation" that we learned in school. I kept wondering: Why are

women those to be sacrificed for men's masterpieces? Why was the artist meant to be a he and not a she? I decided that my role, as an artist, was to get Ana outside those walls and let her walk freely into my poems and plays to tell/cry/scream her story. I always have an "Ana" at the center of my stories, in a committed effort to give powerful voices to the countless women sacrificed throughout the history of humanity; to make them heard, seen, appreciated, and loved.

I truly believe that multiple identities and multi-rooted belonging need to be cherished in the contemporary society, not *othered*. In New York City, a microcosm of the world, I learned to respect the diversity of backgrounds and perspectives. All my American plays explore (migrant) stories of "otherness," displacement, marginalization, oppression, and resilience. My Romanian ones, too. My first dramatic poem was *Proscrisa*, i.e., Outcast, about a woman running from the abusive men in her life. I call myself an ARTivist. I might be a nomad too, like my ancestors. All my artistic work is situated at the fluid intersection of women's issues, queer perspectives, ethnic/race studies, and theatre for social change/justice.

Activities

1. Visit virtually or in person Ellis Island. Read about women who came to the United States either as wives, married women with kids, or alone. Try to find as much information from their respective story of immigration as possible. Then, in 500–700 words create a monologue as if you were one of those women. Be guided by your own understanding of your findings based on research. This is not a perfect reconstruction of a real destiny, but an exercise in respectful imagination. When completed, each reads their piece, followed by a conversation about immigration then and now, real and imagined, thus constantly shifting perspectives. The session ends by paying respect to a nearby iconic presence, i.e., the Statue of Liberty – not accidentally a woman of *foreign* ancestry.
2. Find a *classic* story/narrative about rape as presented in literature/mythology. Identify a disturbing/devastating moment and rewrite it so that the outcome changes drastically and it empowers female voices.

Notes

1 While the play was performed in Romania, for this project I was only given the English version. Hence, in this final chapter, all the quotes come from the original script.
2 "How Did Moldova and Romania Become Separate in the First Place?" https://history.stackexchange.com/questions/30778/how-did-moldova-and-romania-become-separate-in-the-first-place
3 "I Love America. That's Why I Have to Tell the Truth about It" by Viet Thanh Nguyen.
4 Cătălina Florina Florescu. *Transnational Narratives in Englishes of Exile* (2018).
5 "The Long-Term Effects of Sexual Assault": www.uclahealth.org/news/the-long-term-effects-of-sexual-assault
6 In the portion "In their own words," readers will see how the playwright has an opposite take on the scene and the two women's expected solidarity. As a woman myself, I must fight to destroy toxic patriarchy at all costs; however, in the play itself this moment simply does not exist! The playwright answered my questions years apart from the time when she wrote it originally. While I will constantly support and respect her points of view, I refuse to treat the moment in the play lightly or give it a different reading. I revisited the scene several times, and each time I felt Nadia's abandonment as a clear sign of women still not being empowered to stand up for their rights. A volume on intersectionality should do better!

Post Scriptum

Writing in diaspora about Romanian female playwrights is always a wonderful opportunity to discover trends and voices, and to see how, regardless of our identity markers and geographical location, we fight for our well-deserved visibility and the emancipation of Romanian officials who still treat dramatic arts poorly. For example, in Romania, theater is not a part of the curriculum as an independent course on its own, or as an extracurricular activity. If/when plays are studied, the playwrights are typically male, white, heterosexual, and, in many cases, dead. How is that for a flagrant intersectional infringement on the powerful emerging body of work produced by Romanian female playwrights?! Furthermore, the budget invested in education is ridiculously low when compared to other ministries. The rate of functionally illiterate population has been increasing rapidly. If theater is out of the curriculum, one cannot possibly think that there is room for drama therapy. Instead of applied and up-to-date courses that could be cognitively beneficial for Romanian kids and teens, they are enrolled in mandatory religious studies classes with a clear focus on imposing (debatable) Christian values with solid patriarchal notes.

However, since I cannot remedy these problems, maybe I should share something personal. My story of why and how I fell in love with theater could potentially serve as an inspiration to others. I grew up in a house full of feminine energy. My father was the only man at the table. I was born and spent the first fourteen years of my life in communism. When my older sister and I played with toys, one of our favorite games was to pretend they were actors and actresses reciting lines of poetry, short stories, and dramatic

literature. We "assigned" them roles and, by taking turns, we delivered those lines in a joyful way, not once caring if we were good or bad at what we were doing. We were totally immersed in this activity, so much so that our sense of time escaped us on many occasions. When my mother died when I was seventeen, I used theater to help me deal with the huge loss and trauma. I listened to radio plays, watched plays on TV, read plays, reviews, and other studies, and later, as an undergraduate student in Bucharest, went to see live performances. I consumed a lot of theater so that the longing and suffering did not consume me instead. When I came to the States, I decided that the Ph.D. program in Comparative Literature was not quite what I needed professionally, so, I focused on medical humanities using plays, films, music, artworks, and medical textbooks as my primary sources for *research*. When my son was born, all those silly times that I had spent with my sister returned. In 2011, I took a leap of faith switching from analytical to creative writing. If theater had not been in my life as a loyal companion, I would not be here today. The moral of this personal story is that I found an ally in theater and I can speak from personal experience of its irreplaceable therapeutic values.

As a token of my appreciation, I wanted to conclude my pedagogical writing career by releasing a volume that is unique on many levels, from its multilinguistic approach to its applied activities. Just as much as I love and respect critical analysis, it is high time we let non-traditional approaches become a part of the academic discourse. I take a lot of pride in having used only my voice and the playwrights' because, in doing so, I produced a volume that has a more relatable feel. In recent years, women have proven yet again that our way of thinking is reflective of our refined emotional intelligence; that is, we care a lot for our personal histories, we cherish our roots, and, so, we do not have to march in the streets anymore because we know who we are! Our so-called maternal instincts have spilled into many directions and now it does not even matter whether we are or are not mothers in real life. What matters is caring for our body/mind and staying true to our mission to create visibility and representation for as many female-identifying playwrights as possible. That said, in this volume, I could not include other prominent figures such as Stela Giurgeanu, Lia Bugnar, Gianina Cărbunariu, Alina Nelega, Oana Hodade, et al.

Instead of a conclusion, I propose three activities. The first one is inspired by Oana Cajal, a Romanian born playwright and visual artist who lives in Canada. As shown in Figure 11.1, she uses the American flag to speak about the immigrant experience. She creates a strong message that empowers those who have experienced displacement. Even if it may not pertain to everyone, it is still refreshing to switch perspectives. No matter what made someone leave their country of birth, that experience is an opportunity for self-evaluation and growth. The other verbal message reads "luck maybe," but it is not finished. Thus, your challenge is to create two strong, personal statements where the active voice is

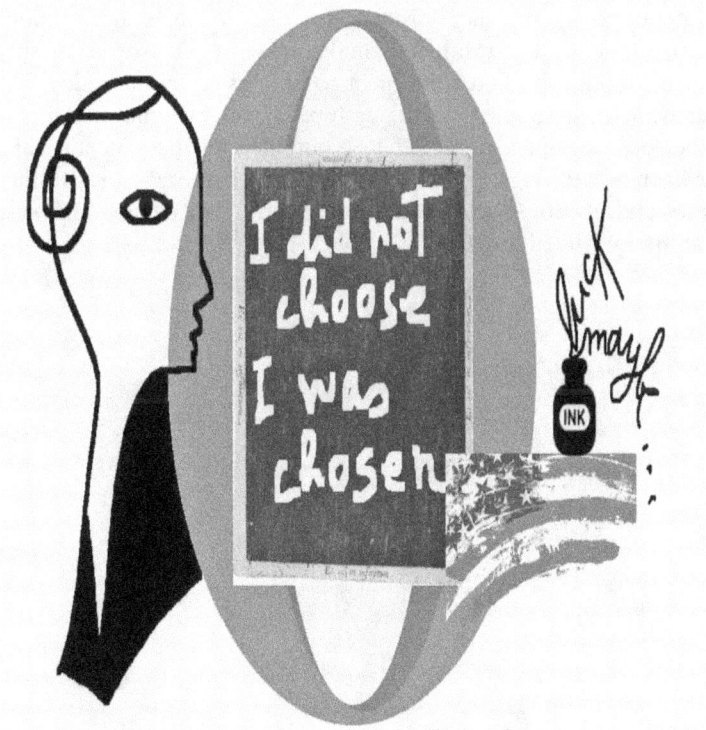

Figure 11.1 "Picto-impulse" by Oana Maria Cajal. 2021.
Reproduced with permission from the playwright.

reversed to passive, and another sentence where you define what luck is for you and give a personal example.

The second activity is an invitation to revisit all chapters and, on your second reading, to group the female playwrights based on how they approached the theme of intersectionality, look more closely at their style, and notice the goals of their respective plays. In writing, choose two authors and write them a letter.

For the final activity of this volume, read ten poems written by female writers, of which at least three should be Romanian. Write down impactful words from their poems. Cut them out and put each word in a hat. In total, you should have 15–30 words. One by one, extract words until there are none left. Arrange them to create a dramatic found-*word* collage. Both Trista Tzara (Dada Movement co-founder) and Herta Müller (Nobel Prize winner in Literature) – Romanian born writers – used to create such random lyrical poems. The result may make no sense whatsoever or surprise you deeply. Take a moment to immerse fully in the joy that came with a simple, playful gesture. Then, imagine an amphitheater in an open space. Recite "your" new dramatic poem. Take a deep breath. It is very likely that you have moved closer to theater and, in doing so, you are going through a deeply *cathartic*, womanly guided moment.

Miscellanea

Appendix

In keeping with the innovative nature of the book, in which the women's voice was not altered by anyone else's, but gently touched by mine, please find the questions that each was generous to answer: *What was the source of inspiration for your play? What motivated you to write it?* ‖ *What is your favorite part in the play even if it is difficult to choose?* ‖ *What do you want the audience and/ or the readers to leave with after seeing and/or reading your play?* ‖ *How do you wield your own brand of feminism in your play?* ‖ *How is your piece provoking to change the still white male dominated world of the arts?* ‖ *How would you define intersectionality and what does it mean in relationship to your work?*

Suggested Bibliography

Clarke, Arthur C. *Profiles of the Future: An Inquiry into the Limits of the Possible*. New York. Harper & Row, 1962.
Crenshaw, Kimberlé. "Demarginalizing the Intersection of Race and Sex: A Black Feminist Critique of Anti-Discrimination Doctrine, Feminist Theory, and Antiracist Politics." University of Chicago Legal Forum. 1989 (139–176). https://chicagounbound.uchicago.edu/uclf/vol1989/iss1/
Florescu, Catalina Florina. *Transacting Sites of the Liminal Bodily Spaces*. Newcastle upon Tyne, UK, 2011.
―――― and Sheng-mei Ma. *Transnational Narratives in Englishes of Exile*. Lanham. Rowman & Littlefield, 2017.
Klara, Alexandra. "Is Feminism Still a Real Thing in Romania?" *Medium*. 2018. https://medium.com/@jkalexandra1/is-feminism-still-a-real-thing-in-romania- 7607744c4f2

Nguyen, Viet Thanh. "I Love America. That's Why I Have to Tell the Truth about It." *Time Magazine*, 2018. https://time.com/magazine/us/5455477/november-26th-2018-vol-192- no-22-u-s/

Important Topics to be Educated On

What is gender gap depression? || Who were the Dacians? || What is the history of the Iron Curtain? || What is the origin of the Berlin Wall? || Why aren't Moldova and Romania united? What is Perestroika? || Who are the Roma people? Have you ever heard of Porajmos? What is maternity leave? What is postpartum? || What is sexual education? How many teen pregnancies are reported annually? || What is conversion therapy? || What is a sex worker, synchronically and diachronically? || Which countries have legalized same-sex marriages worldwide? || What is an exodus, historically and presently? || What is a migrant worker? || What is human trafficking?

Memory Tune-up

Intersectionality || Survivor's Guilt || Salem's Witches Trial || Postcolonialism vs. Globalization Sexual identities || Wage Gap || The Equal Rights Amendment Ratification || Schrödinger's Cat || Intergenerational Trauma || Immigration Laws || Relived Sexual Abuse || Dictatorships || European Union & Schengen Area.

Romanian NGOs to Support

ACCEPT (LGBTQ organization) || *SOS, Satele Copiilor*, an organization for vulnerable kids without families || *UNICEF* Romania || *Feminism Romania* || *Centrul Filia*, an organization for battered, homeless women || *Amare Romentza*, NGO Roma || *Declic*, a platform that seeks equity & social justice || *Sexul vs. Barza*, a platform for sexual education.

About The Playwrights

Alexandra Badea is a Romanian born French playwright. She published ten plays and one novel, some translated into several languages. Her plays have been produced in National Theatres in France and across Europe and a few have even been adapted for the radio. Badea has had several residencies in Japan, Russia, Germany, Canada, and has been awarded several grants by the Theatre National Center, the Book National Center, the Ministry of Culture, etc.

Carmen-Francesca Banciu was born in Romania and studied Byzantine Art and Foreign Trade in Bucharest. As a result of being awarded in 1985 the International Short Story Award of the City of Arnsberg for the story "Das strahlende Ghetto," she was banned from publishing her work in Romania. In 1991 she accepted an invitation extended by the DAAD Berlin Artists-in-Residence program. Banciu lives in Berlin and works as a freelance author and co-editor/deputy director of the transnational magazine *Levure Littéraire*. www.banciu.de/en

Alexa Băcanu has been writing plays that have been staged in both independent and state theatres, and they have been published in cultural magazines and anthologies. She was part of the international program Fabulamundi. She is interested in experimenting with structure and narrative and looks for subjects that are rooted in reality, like social pressure, gender roles, media/pop culture, our relationship with time, psychological disorders such as anxiety, depression, and atypical neurological behaviors.

Ana Sorina Corneanu loves monodrama for the intimacy of thoughts. Corneanu graduated with a degree in acting conferred by the National University of Theatre and Film I. L. Caragiale. She started writing stories and poems in the seventh grade, and in high school she wrote her first

126 *About The Playwrights*

screenplay. The pandemic was the moment when she started and dared to write dramatic pieces as an exercise in surviving. The experience as an actress was important in the construction of the inner dramaturgical discourses of her characters.

Mihaela Drăgan founded *Giuvlipen Theatre Company* dedicated to Roma topics and performers. She was one of the six finalists for the 2017 New York Gilder/Coigney International Theatre Award, which acknowledges the exceptional theatre work of 20 women around the world. She was also acknowledged by PEN World Voices International Play Festival as one of the ten most respected dramatists in the world. In 2019, she was one of the playwrights selected for the acclaimed Royal Court Theatre International Summer Residency in London.

Cătălina Florina Florescu was born on a Sunday in March, one day immediately after the International Women's Day. She holds a Ph.D. in Comp Literature (Medical Humanities) conferred by Purdue University. She teaches theater, writing, and cinema to undergraduates at Pace University, and communication to international graduates at Stevens Institute of Technology. She is the curator for new play festival at Jersey City Theater Center. Dr. Florescu has published 10 books, some analytical, other creative, still others, hybrid. Dr. Florescu collaborated with interdisciplinary scholars, (drama) therapists, (former) cancer patients, LGBTQ actors and writers, political activists, immigrants, veterans, World Health Organization representatives, and various local and international artists. www.catalinaflorescu.com/

Mihaela Michailov holds a Ph.D. in Theatre Studies from the National University of Theatre and Film I. L. Caragiale, where she coordinates the Master of Playwriting. Michailov is the co-founder of the independent space *Replika Center for Educational Theatre*, based in Bucharest, where she has initiated platforms on art, programs of cultural intervention, and shows on themes related to education. Her plays have been translated into Bulgarian, English, French, Hungarian, Italian, German, Greek, Portuguese, and Spanish.

Domnica Rădulescu settled in Chicago where she obtained a Ph.D. in Romance Languages from the University of Chicago. The production of *Exile Is My Home* at the Theater for the New City in New York (2016) was nominated for the New York Innovative Theater Award and won the Outstanding Performance by an Ensemble Cast Award from the Hispanic Organization of Latin Actors. Rădulescu was twice a Fulbright scholar,

About The Playwrights 127

and she is the Founding Director of the National Symposium of Theater in Academe.

Saviana Stănescu is a cutting-edge award-winning Romanian playwright, poet, and ARTivist based in NY. She is the winner of New York Innovative Theatre Award for Outstanding Play (*Waxing West*) and UNITER Award for Best Romanian Play of the Year (*Inflatable Apocalypse*). Ms. Stănescu holds an M.F.A. in Dramatic Writing and an M.A. in Performance Studies from New York University, Tisch School of the Arts, and currently works as an Associate Professor of Playwriting and Contemporary Theatre at Ithaca College. www.saviana.com

Elise Wilk is one of the most performed playwrights from the younger generation in Romania. She studied journalism in Cluj-Napoca, creative writing in Brașov, and playwriting in Târgu Mureș. She teaches playwriting classes at the University of Arts in Târgu Mureș. She took part in international writing programs such as the Forum of the Young Authors at the Wiesbaden Theater Biennale, Hot Ink, and Fabulamundi. https://elisewilk.ro/

Index

activity 91, 105, 119, 120, 122

birth 8, 14, 17–19, 22, 25, 27, 30, 33, 40, 49, 53, 95, 97, 98, 100, 108, 110, 113, 115, 121
body 1, 4, 5, 11–13, 16, 19, 22, 23, 31, 35, 47, 51, 53, 57–60, 63, 66–8, 75, 82, 86, 90, 91, 115, 103, 105, 112, 114, 119, 120
border 15, 32, 33, 77, 83, 103, 116

children 11, 33, 80, 84, 85, 87, 89, 94
citizen 24, 31, 62, 63, 85, 88, 97, 102, 113, 115, 116
communism 31, 33, 35, 36, 62, 83, 102, 119
control 3, 11, 19, 38, 39, 44–6, 53, 60, 62, 74, 92, 98
Crenshaw, Kimberlé 123

depression 13, 17, 20, 21, 23, 113, 116, 124

education 1, 9, 69, 87–9, 93, 119, 124

family 1, 5, 11, 16, 19, 21, 31, 33, 34, 36, 46, 52, 58, 62, 64, 65, 82–5, 88–90, 94

female 2, 5, 6, 9–11, 16, 19–21, 24, 34, 45, 52, 56, 57, 60, 66, 69, 76, 86, 93, 105, 111, 114, 116, 117, 119, 120, 122
foreign 11, 33, 99, 116, 117

history 26, 31, 35, 36, 40, 41, 44, 45

immigrant 31, 40, 46, 69, 95, 103, 113, 115, 116, 121
intergenerational 24, 40, 83, 100, 124
intersectionality 7, 11, 21, 31, 61, 67, 77, 80, 86, 91, 105, 114, 118, 122–4

language 2–4, 33, 86, 92, 105, 111, 113
literature 37, 40, 91, 114, 120, 122
love 6–9, 14, 15, 60, 61, 63, 64, 67, 68, 78, 85–7, 102, 105, 115, 117–20

marriage 4, 6, 61, 62, 64, 67, 68, 81, 124
mother 3–8, 11–13, 16–18, 22, 23, 31, 32, 35, 53, 61, 63–6, 68, 69, 77, 85–7, 89, 91, 92, 95, 97, 98, 101, 102, 106, 120

patriarchy 105, 118
politics 44, 123

racism 43, 45, 48, 105
Romania 1, 2, 4, 6, 8, 9, 11,
 12, 21, 24, 26, 27, 30, 31,
 33, 34, 35, 37, 38, 48, 50,
 61–3, 65, 66, 68, 69, 71, 74,
 82, 83, 87

sex 2, 9, 10, 15, 18, 21, 23, 60,
 62–9, 124

theater 24, 45, 49, 55, 73, 74, 78,
 83, 88, 90, 96, 100, 101, 106,
 114, 119, 120, 122

woman 1, 3–6, 8–13, 16–18, 21,
 30–3, 45, 46, 60, 62–9, 73–5,
 77–80, 87, 90, 93, 100, 117, 118,
 122
work 3, 6, 7, 11–13, 17, 21, 24, 33,
 34, 37, 39, 46, 51–4, 56, 58–60,
 69, 71, 76, 79, 81–3, 85–8, 90–3,
 100, 108, 110–12

For Product Safety Concerns and Information please contact our EU representative GPSR@taylorandfrancis.com
Taylor & Francis Verlag GmbH, Kaufingerstraße 24, 80331 München, Germany

www.ingramcontent.com/pod-product-compliance
Lightning Source LLC
Chambersburg PA
CBHW051750230426
43670CB00012B/2231